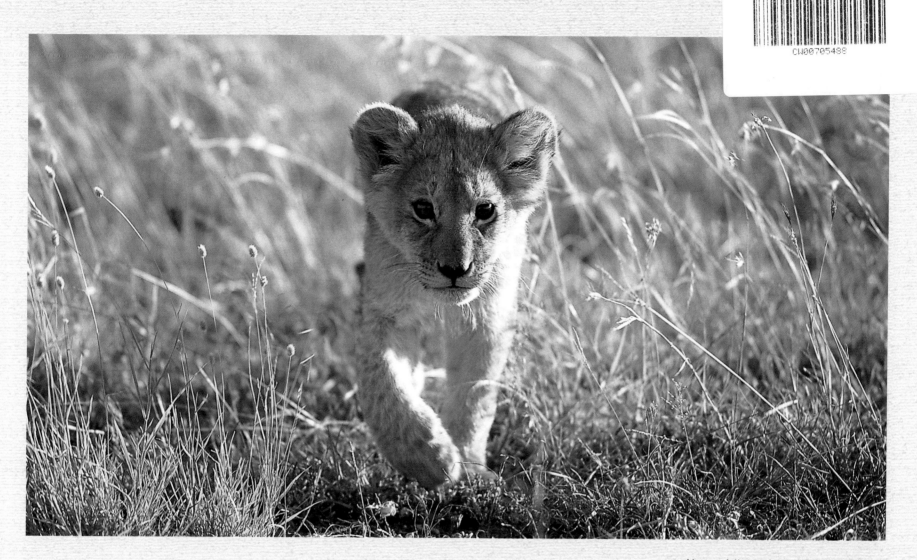

Above: A lion cub explores its surroundings. It will be a year before it is able to fend for itself, and weaker cubs often do not survive.

Overleaf: During the breeding season, female impala will gather in a small range vigorously defended by a territorial male.

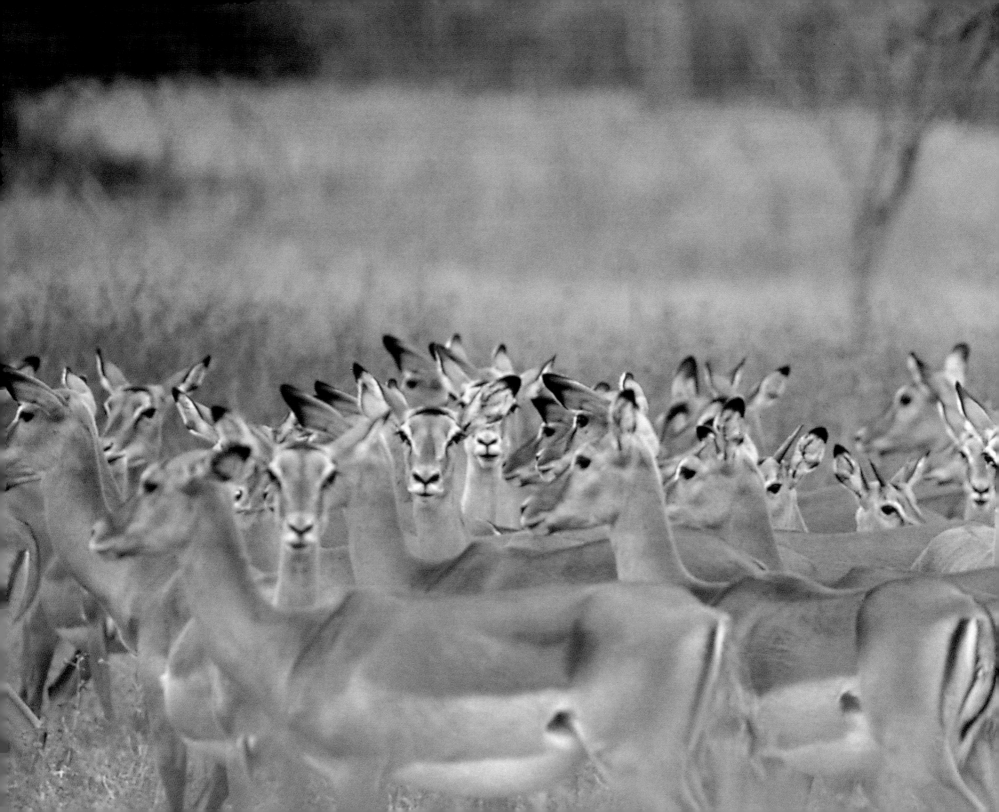

East Africa Alive

Camerapix Publishers International

NAIROBI

DUNCAN WILLETTS • JOHN DAWSON

This book was designed and produced by
Camerapix Publishers International
P.O. Box 45048, 00100 GPO Nairobi, Kenya
E-mail: camerapix@iconnect.co.ke

© Camerapix 2004

ISBN: 1-904722-14-8

Production Director: Rukhsana Haq
Photography: Duncan Willetts
Text: John Dawson
Design: Sam Kimani

Special thanks to Karl Amman for use of his valuable photography on pages 30, 34, 58, 59 (left), 66, 69, 84, 86 (left), 87, 92-93, 94, and 96 (above right, below right).

Colour Separations: United Graphic, Singapore
Printed by: UIC Printing Press, Singapore

Opposite: The buffalo is one of the most widespread of the African plains animals, and is found everywhere there is grassland and access to water.

Following pages: The throat fringe helps to distinguish these greater kudu from their lesser kin. The kudu is almost exclusively a browser, feeding on a wide variety of leaves, herbs, and flowers.

The cheetah, with its lithe body, long legs, and back like a coiled spring, is perfectly adapted to high-speed pursuit.

Crocodile, Lake Baringo, Kenya. Up to five metres in length, the crocodile is a design success story; it is little changed from the creature that terrorized primeval swamps millions of years ago.

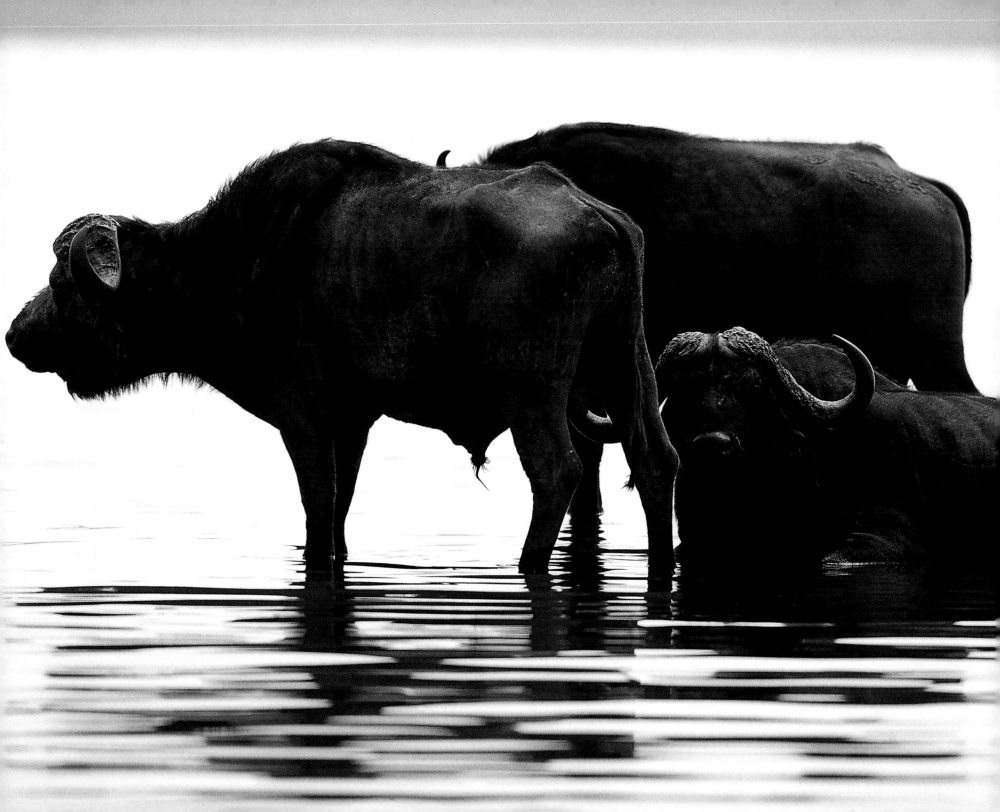

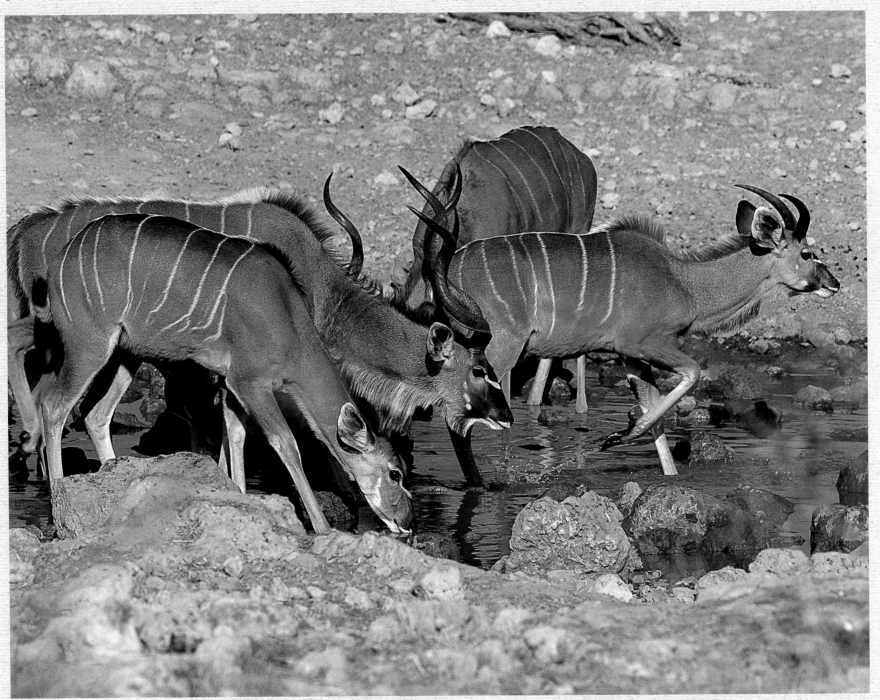

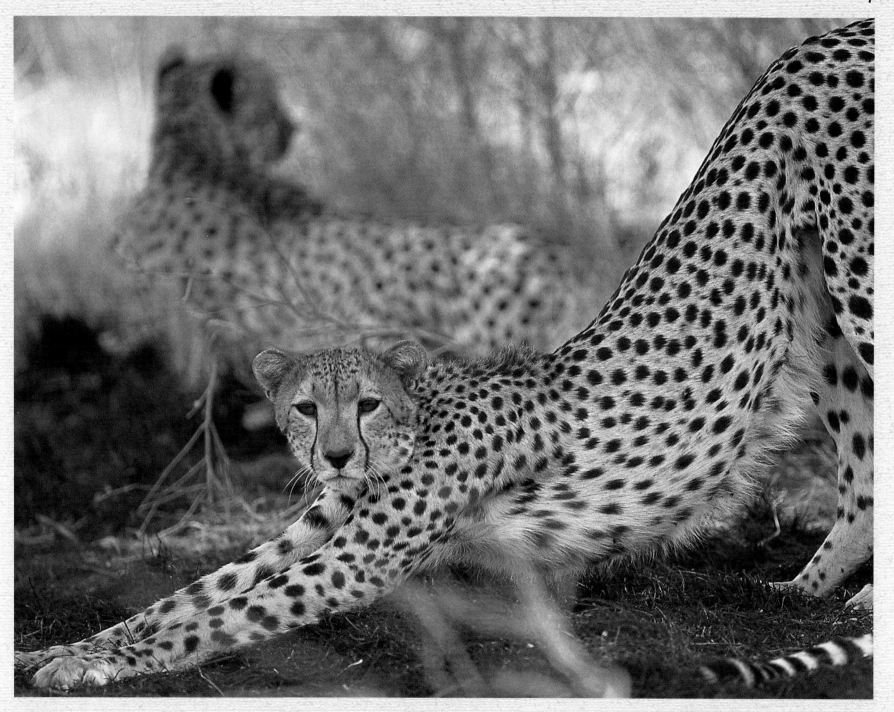

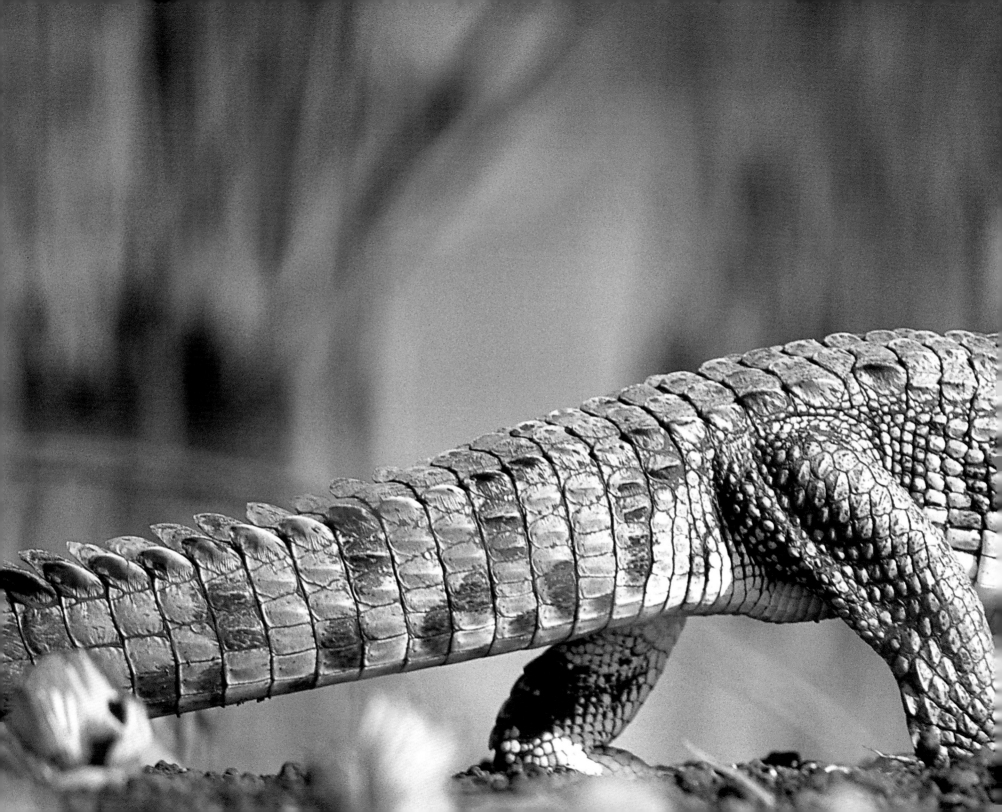

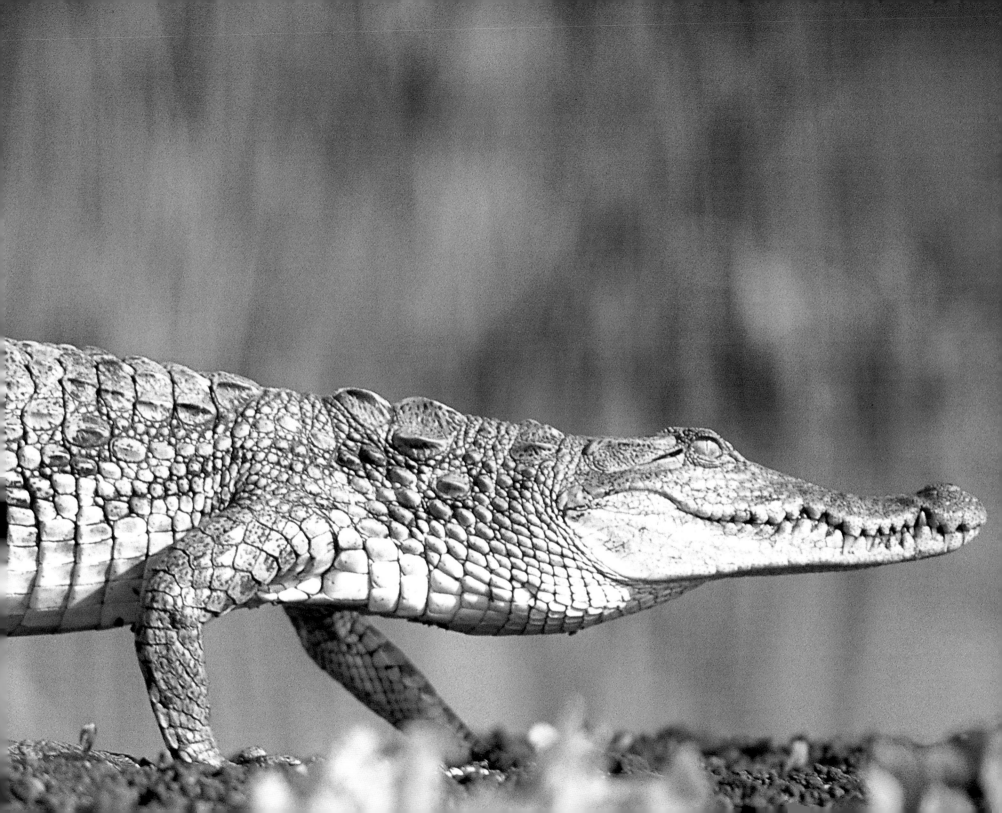

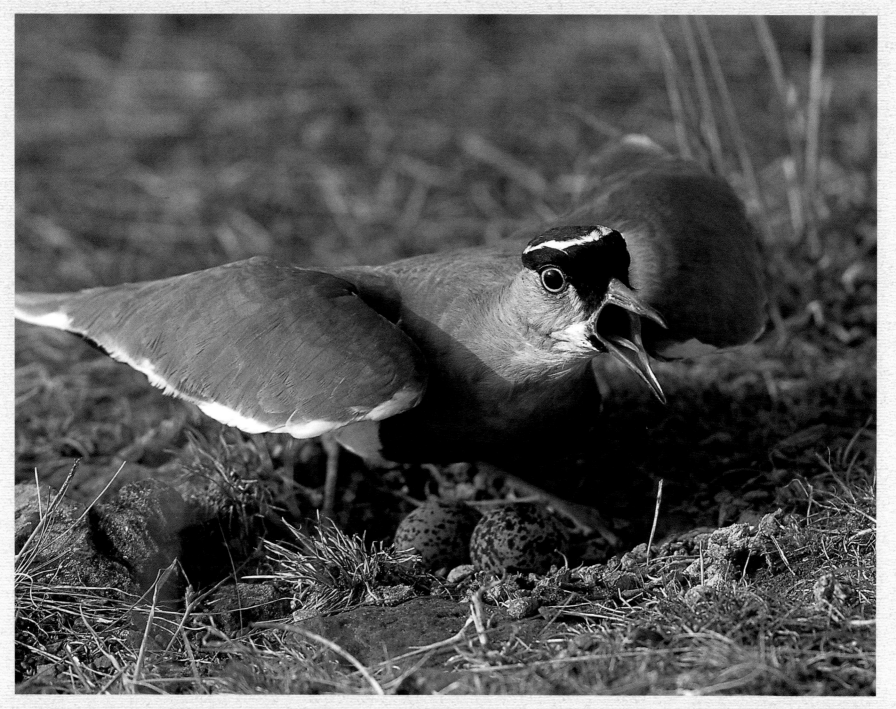

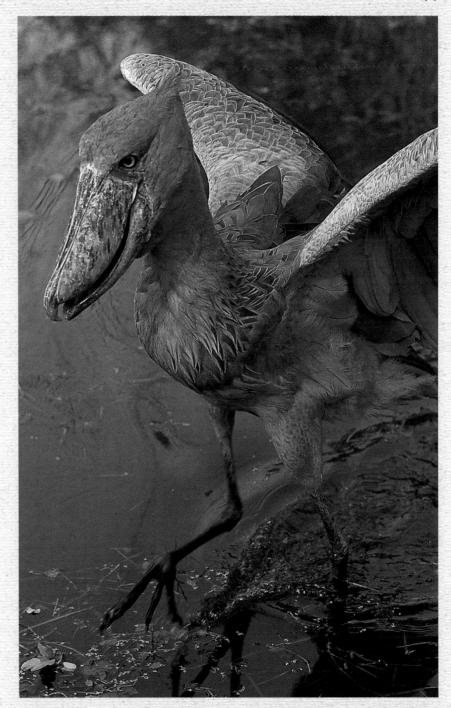

Opposite: A crowned plover protects her clutch of eggs. Though the nest is a mere scrape in the ground, the mottled eggs are almost invisible against the stony terrain.

Right: The shoebill is a unique, elusive inhabitant of the papyrus swamps fringing Lake Victoria. Its massive bill easily accommodates its favourite delicacy, lungfish.

• Contents •

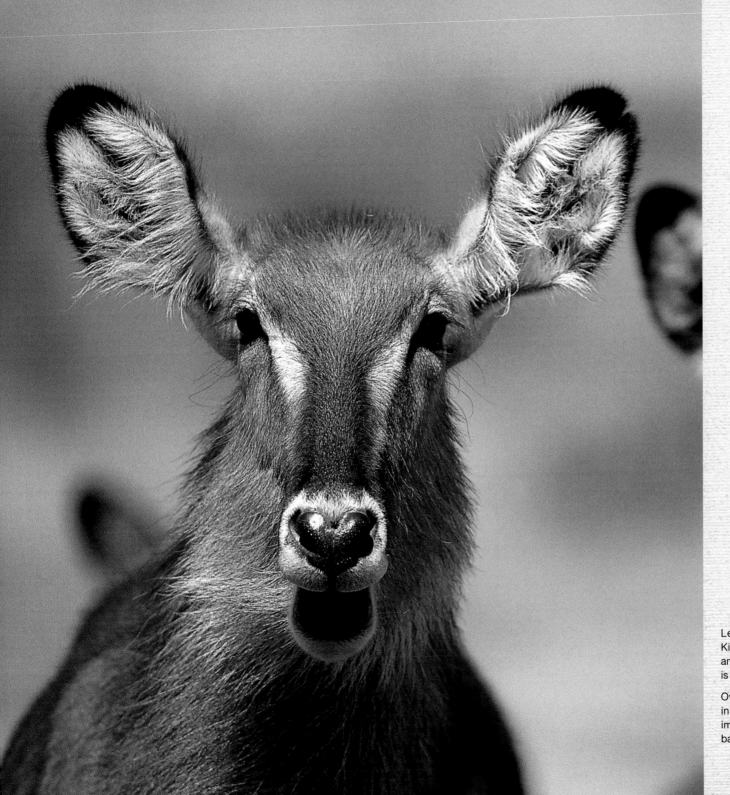

Left: The waterbuck (pictured here at Kidepo National Park, Uganda) is a robust and stately antelope. As its name implies, it is closely associated with wetlands.

Overleaf: A herd of elephant on the move in Amboseli National Park, Kenya, with the imposing bulk of Mount Kilimanjaro as a backdrop.

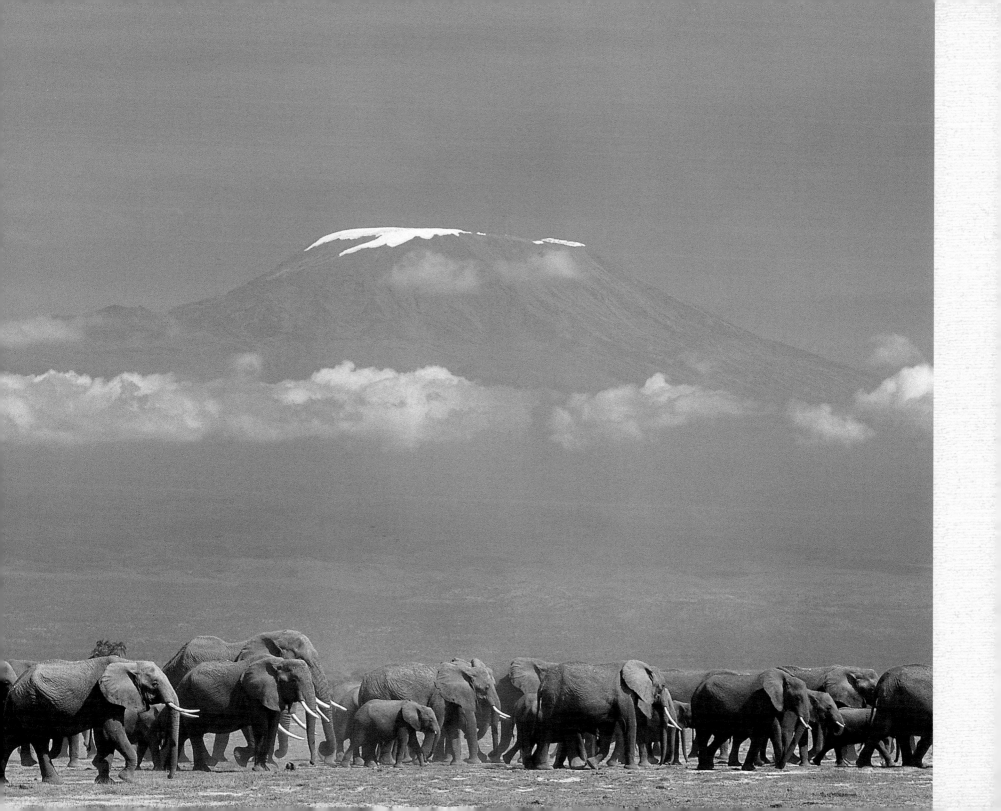

• East Africa Alive •

There are certain places that stir the imagination, quicken the heart, awaken a yearning within the soul. Suddenly we find ourselves far removed from the complex cares of modern society, transported in our minds not just to a faraway destination, but to a distant time, deep within our primeval memories, when our instincts were still attuned to our natural surroundings. Perhaps no other place arouses such feelings as does East Africa, the very cradle of mankind, source of the wild lifeblood that still courses through our veins.

And the wildness is still there. In East Africa, Nature has been at her most generous, bestowing Kenya, Tanzania, and Uganda with a variety and abundance of riches unrivalled on the planet. A manta ray glides above the coral reef; an impala dances out of reach of a lion's flashing claws; a silverback gorilla reclines on a home-made bed of branches and leaves. Multiply such scenes by a million, every day of the year.

The abundance starts where the warm waters of the Indian Ocean bathe the living rock of the coral reef that fringes the coasts of Kenya and Tanzania. The reef is in fact the external skeleton of delicate animals, polyps, which excrete calcium carbonate to build up one of the most impressive – and beautiful – defence systems on Earth.

The clear waters of the reef effervesce with activity. Cardinal and butterfly fish sweep past in quivering, darting shoals. Others, such as the octopus and the moray eel, secrete themselves in dark crevices. From the defiant ugliness of the crocodile fish to the shimmering glamour of the Spanish dancer, all are vital strands in this fascinating web of life. Beware of the beguiling sirens of the reef, however – the attractive streamers that bedeck the lionfish and scorpionfish conceal a painful sting.

Backing the coral reef is a narrow coastal zone of great importance not only regionally but globally. The food-rich shoreline, for example, is temporary home to vast numbers of migrant birds finding refuge from the northern winter – scurrying sanderlings, stately curlews and godwits, swooping terns.

Of even greater consequence is the Arabuko-Sokoke Forest, one of the last remnants of the tropical forest that once fringed this entire coastline. Although only 400 square kilometres in extent, this habitat has a significance out of all proportion to its size. It hosts a large number of scarce or endemic species, including the yellow-rumped elephant shrew, the enigmatic Clarke's weaver, and the Sokoke scops owl (only discovered as recently as 1965). Along with nearby Mida Creek, this area has been designated a UNESCO biosphere reserve.

Behind the coastal belt the land soon rises to the interior plateaux of East Africa, a seemingly endless world of thorn bush, acacia, and savannah grassland. Much of this territory is now settled, of course, and the main animals to be seen are goats, cattle, and sheep. But there remain extensive areas where the old mammals of the African bush still enact the timeless rituals of birth, survival, and death.

The massive expanses of Tsavo East and West national parks typify this zone, and harbour a surprising diversity of landscape and ecosystem. At the waterhole below the hulking outcrop of Mudanda Rock, in the eastern park, milling herds of elephant, red with Tsavo dust, gather to drink and bathe. Perhaps the jewel in the western park's crown is Mzima Springs, erupting with all the force of the mythical River Alph as it discharges 10 million litres of water per hour to irrigate a veritable Garden of Eden amid the bush, inhabited by hippo, crocodile, barbel, and waterfowl.

The birdlife of Tsavo is eye-catching and varied: golden-breasted starling, perhaps the most stunning of a spectacular family; rosy-patched shrike; the paradise flycatcher, proudly flaunting its long chestnut tail as it hawks for insects; amethyst, violet-breasted, and collared sunbirds dashing from flower to flower; and the imperious martial eagle soaring high above. At Ngulia Lodge thousands of Palaearctic migrants, drawn to the lodge lights, are ringed each year. Marsh warbler, sprosser, common whitethroat, and river warbler are among the most numerous.

Next door to Tsavo, dominated by the imposing snow-capped colossus of Mount Kilimanjaro, lies Amboseli National Park. It covers a relatively small area, but contains a range of habitats that make it a microcosm of East Africa: here are grassy plains, acacia woodland, thorn bush, and the swamps and marshes bordering Lake Amboseli, popular with the herds of elephant that bathe and feed in the cooling waters.

Selous Game Reserve, home to a million wild animals, is the south Tanzanian equivalent of Tsavo – 50,000 square kilometres of more or less virgin bush, through which it is

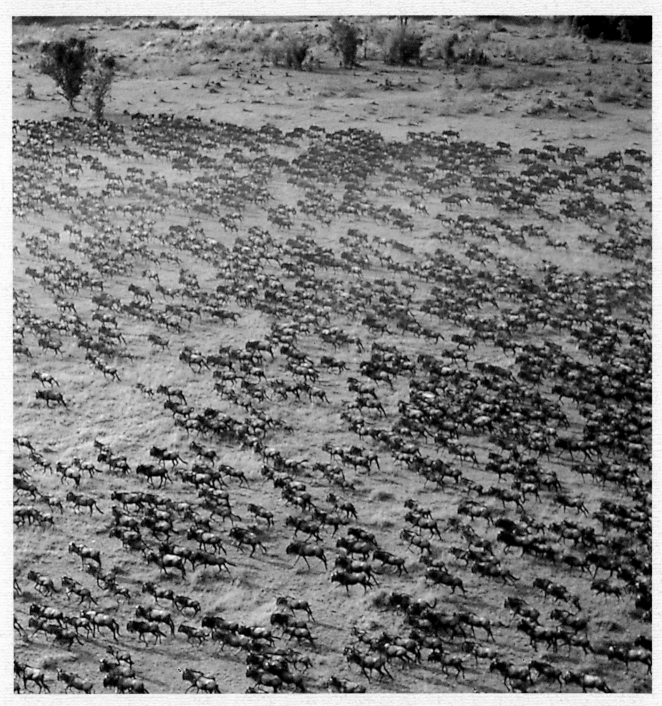

Left: The sheer scale and grandeur of the wildebeest migration is apparent from this aerial photograph of a huge herd sweeping across the Maasai Mara plains in Kenya.

possible to travel for days without seeing another human being. It is sanctuaries such as these that give rise to the hope that the unique flora and fauna of Africa may yet be preserved for posterity.

Well to the north of these parks, Samburu National Reserve holds some unusual mammals rarely seen further south, including Grevy's zebra, side-striped hyena, beisa oryx, and reticulated giraffe, the tile-patterned cousin of the Maasai race. Watch out, too, for the ostentatious vulturine guineafowl, strutting through the bush in proud flocks.

The true rolling savannah grasslands are found in the Maasai Mara National Reserve in Kenya, and across the Tanzanian border in the Serengeti National Park. They support huge populations of antelope – wildebeest, topi, Grant's gazelle, Thomson's gazelle, impala, and eland – as well as buffalo and zebra. The annual migration of wildebeest and other species through this ecosystem, including the dramatic traverse of the Mara River, is one of the most magnificent natural spectacles on the planet. The keys to this mouth-watering open-air larder are held by the big cats and other scavengers, including lion, leopard, cheetah, hyena, and jackal; and, sweeping down out of the sky, vulture and marabou stork.

In many ways the most unexpected of the Kenyan parks is one of the smallest – the Nairobi National Park. Almost unbelievably, this wildlife haven survives on the very fringe of one of Africa's biggest cities, the final destination of herbivores making the dry-season trek northwards up the Kitengela corridor. This is perhaps the easiest place in Kenya to see black rhino, with the somewhat incongruous skyline of Nairobi city centre as a backdrop.

Cataclysmic earth movements have periodically convulsed East Africa, rumpling its surface into enormous corrugations. The volcanic extrusions of Mount Kenya, Kilimanjaro, and the Aberdares are tall enough to introduce alpine flora and fauna to the very equator. Elusive creatures, such as the giant forest hog and the bongo, stalk their slopes, and the birdlife is also distinctive – green ibis, rufous-breasted sparrowhawk, taccazze and golden-winged sunbirds. The Ngorongoro Crater, in Tanzania, is the collapsed shell of an ancient volcano, its forested slopes looking down on a multitude of birds and animals attesting to the beneficence of the lakes, woods, and grasses that spread across its floor.

Perhaps the most emphatic result of these earth movements is the awesome gash in the earth's surface known as the Great Rift Valley. The floor of this split is decorated by a paternoster of lakes, each with its own character. From the giant inland sea of Lake Turkana in the north to the stifling salt basins of Lake Natron and Lake Eyasi in the south, these bodies of water provide sufficient nourishment to sustain unrivalled congregations of birds. Millions of flamingos throng the soda lakes of Bogoria and Nakuru, and the fresh waters of Baringo and Naivasha attract white and pink-backed pelican, great and long-tailed cormorant, goliath and purple heron, and the lord of them all, the fish eagle, whose evocative yelping cry echoes across the lakes' still waters. To the west, and by far the largest of the lakes, is Victoria, where the remarkable shoebill stork still patrols the lakeside marshes.

On the inland fringe of East Africa, towards the centre of the continent, the nature of the vegetation changes. Here are the outposts of the exuberant rain forests that cover much of West Africa. In Kenya this habitat is represented by Kakamega Forest, its canopy sheltering a pot-pourri of exotic birds found nowhere else in Kenya: great blue turaco, grey parrot, blue-headed bee-eater, and a host of wattle-eyes, illadopsises, and greenbuls which confound even the expert.

It is on the very western edge of Uganda, however, that these forests can be seen at their misty, luxuriant best, in the Ruwenzori Mountains, the Bwindi Impenetrable Forest, and the Virunga volcanic range. The latter two are among the last natural homes of the mountain gorilla, and sharing time and space with these powerful yet gentle primates is surely the ultimate safari experience. In the shadow of the Rwenzoris, the water meadows of the Queen Elizabeth National Park are grazed by defassa waterbuck and Uganda kob, and the arrestingly coloured grey-crowned crane, Uganda's national bird, can also be seen.

Here, across this vast and varied landscape, is East Africa – East Africa alive.

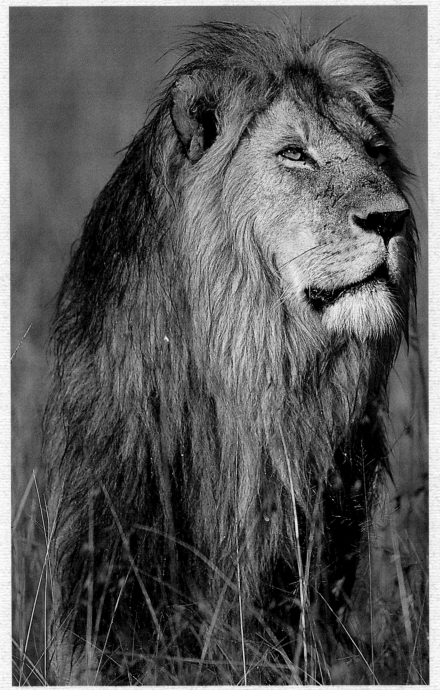

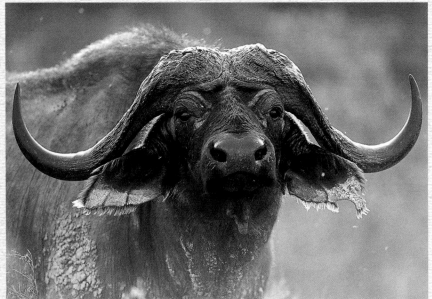

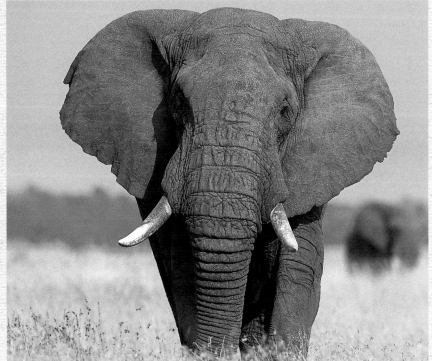

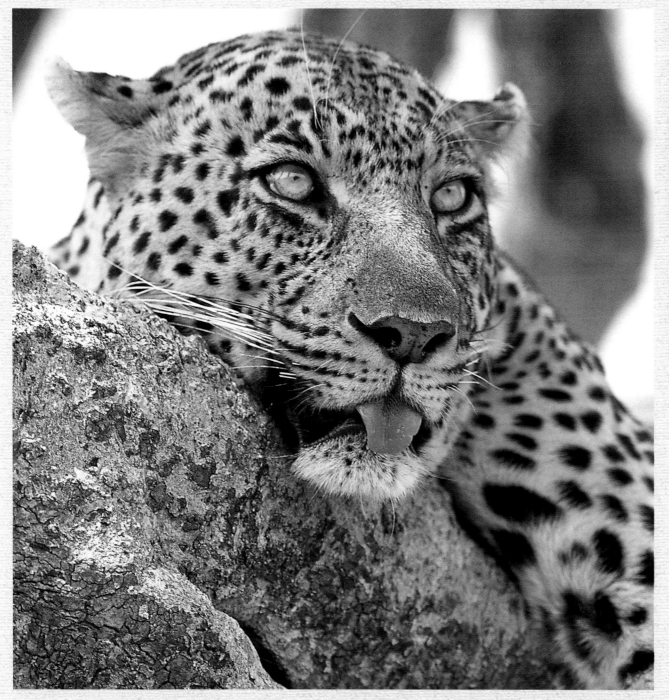

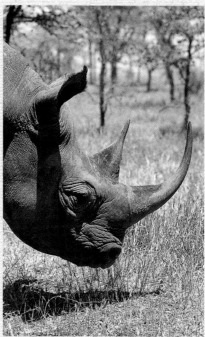

The so-called Big Five: the regal bearing of the lion, the fearsome horns of the buffalo, the commanding presence of the elephant, the stealthy alertness of the leopard, the awesome defences of the rhino.

Overleaf: Viewing this herd of common zebra in the long grasses of the Maasai Mara National Reserve, Kenya, it is easy to imagine the disorienting effect of the sea of stripes on a predator.

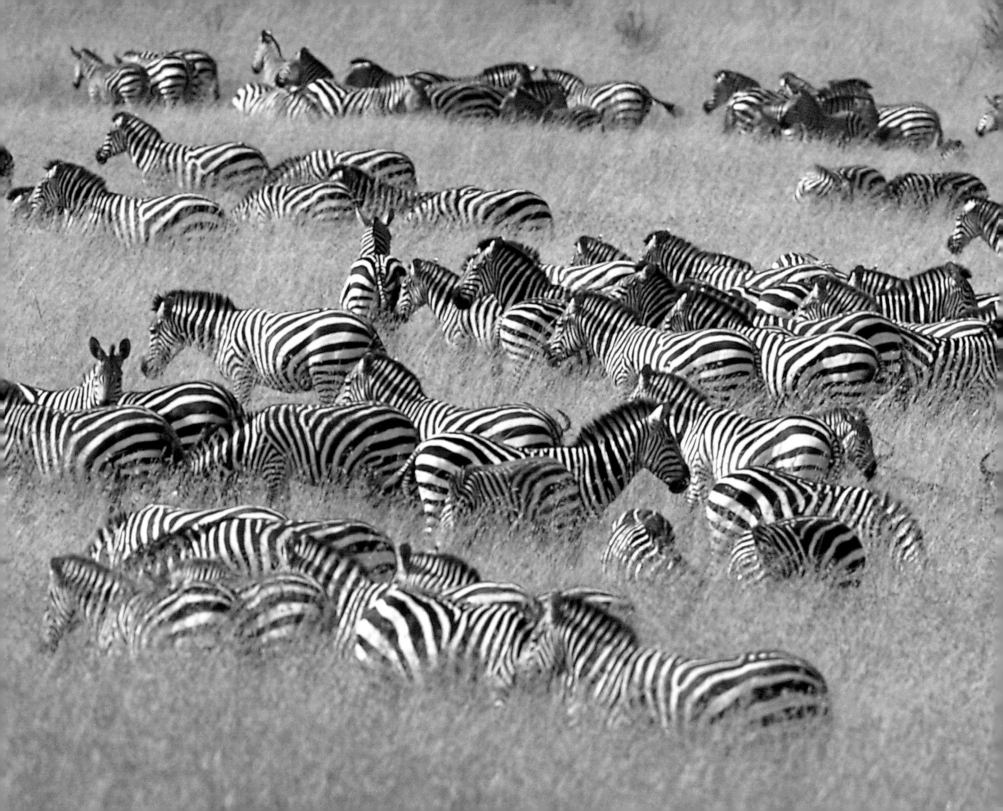

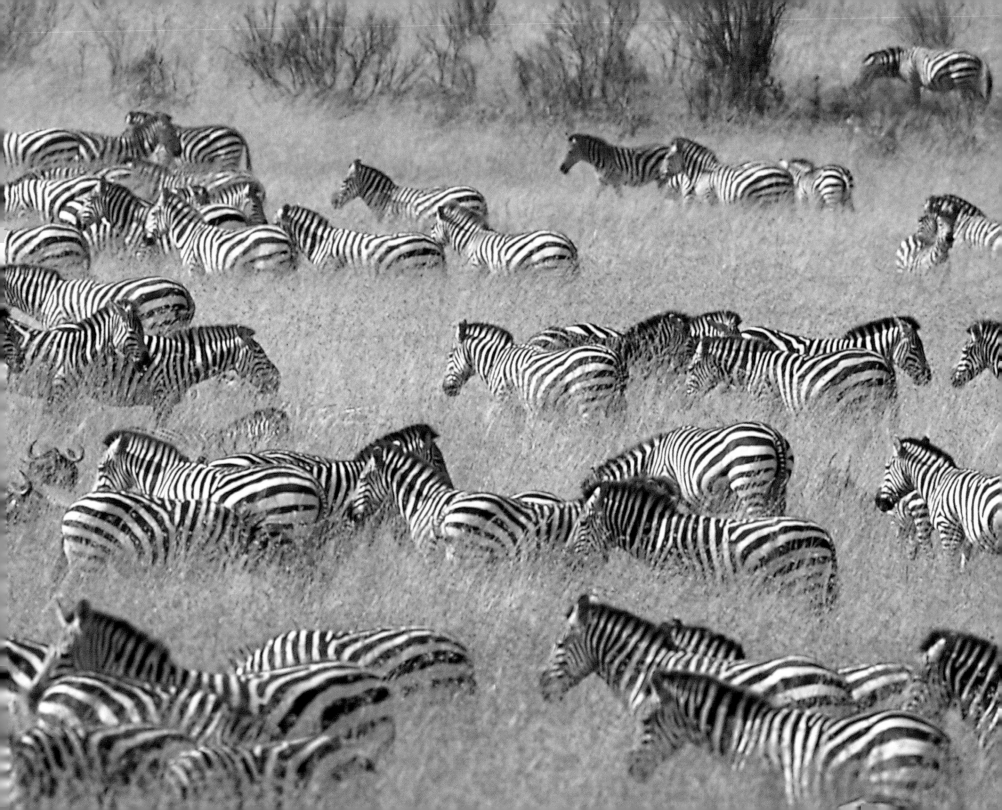

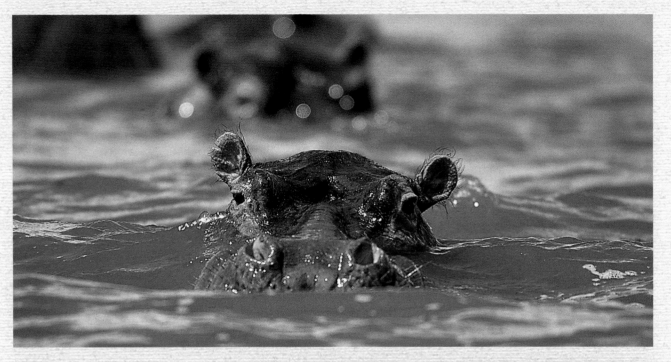

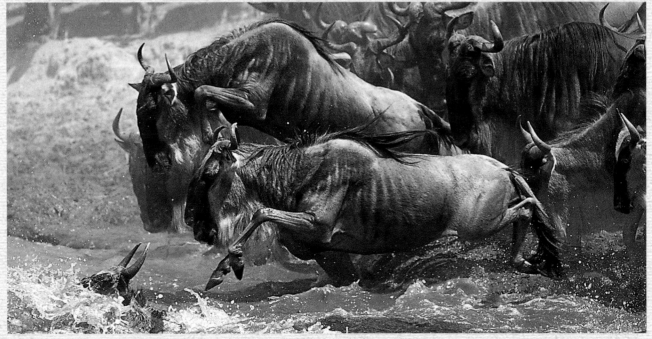

Above Left: Hippo, Queen Elizabeth National Park, Uganda. The hippo's ears and nostrils close when it dives, and it can stay submerged for up to six minutes, rising to the surface to breathe even in its sleep.

Left: Wildebeest hurtle headlong into the Mara River, one of the major barriers they must cross on their annual migration.

Opposite: By contrast, a loose herd of reticulated giraffe wander across the almost-dry river bed of the Ewaso Nyiro River, Samburu National Reserve, Kenya.

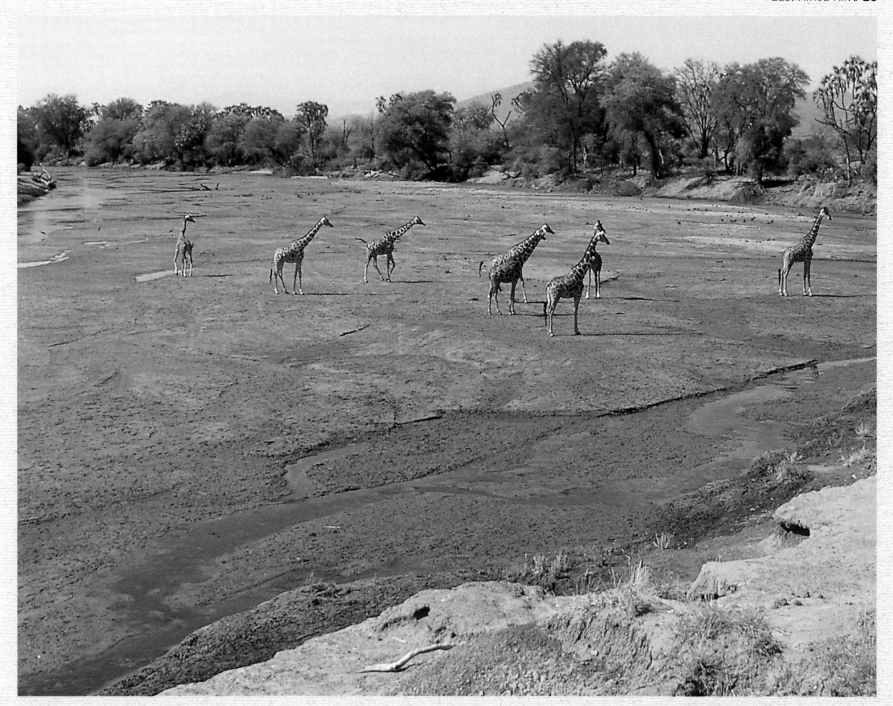

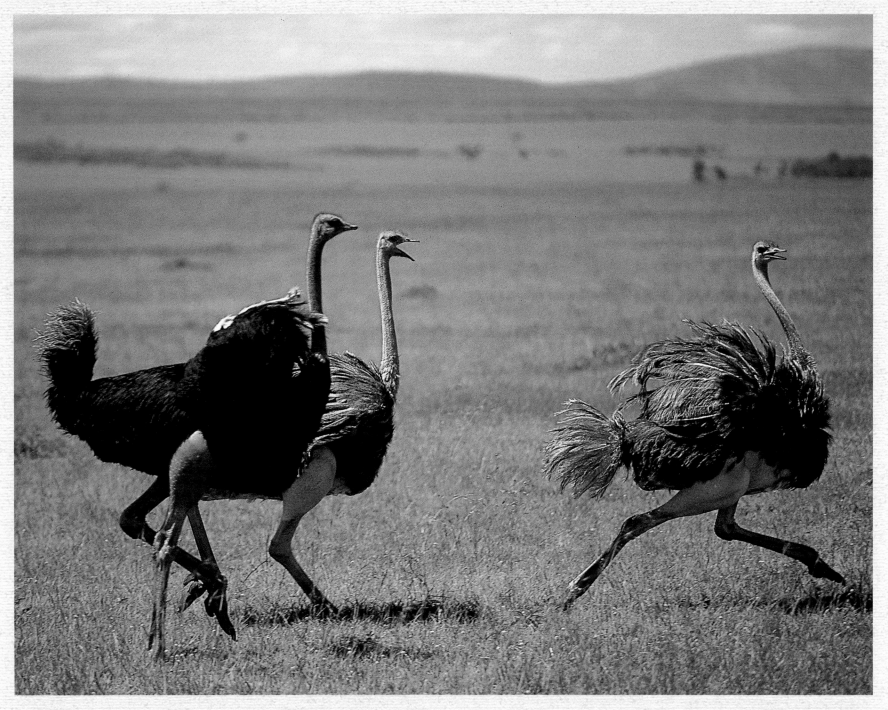

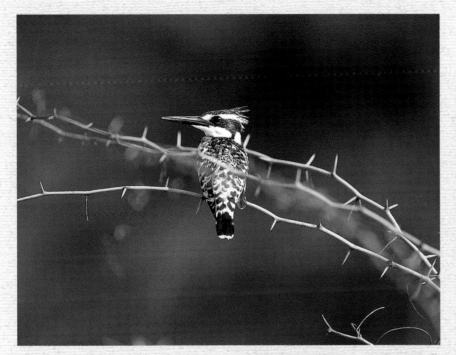

Opposite: The neck and legs of this breeding male Maasai ostrich flush red with excitement as it frolics with a pair of females.

Above: The pied kingfisher is one of the more conspicuous members of its family; it hovers a few metres above the water, scanning for fish below before plunging in pursuit.

Right: The leggy secretary bird strides across the grassy plains searching for snakes and other prey.

Far right: The withering glare of the martial eagle, in Kenya's Maasai Mara, would intimidate any intruder hoping to share the meal it is shielding with outspread wings.

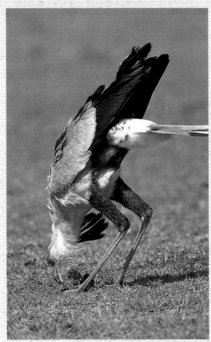

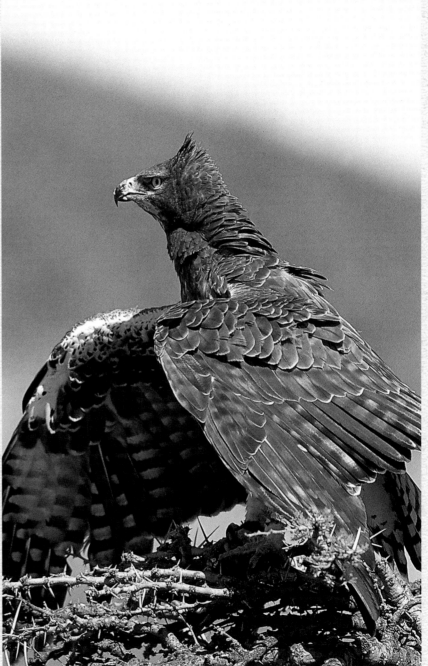

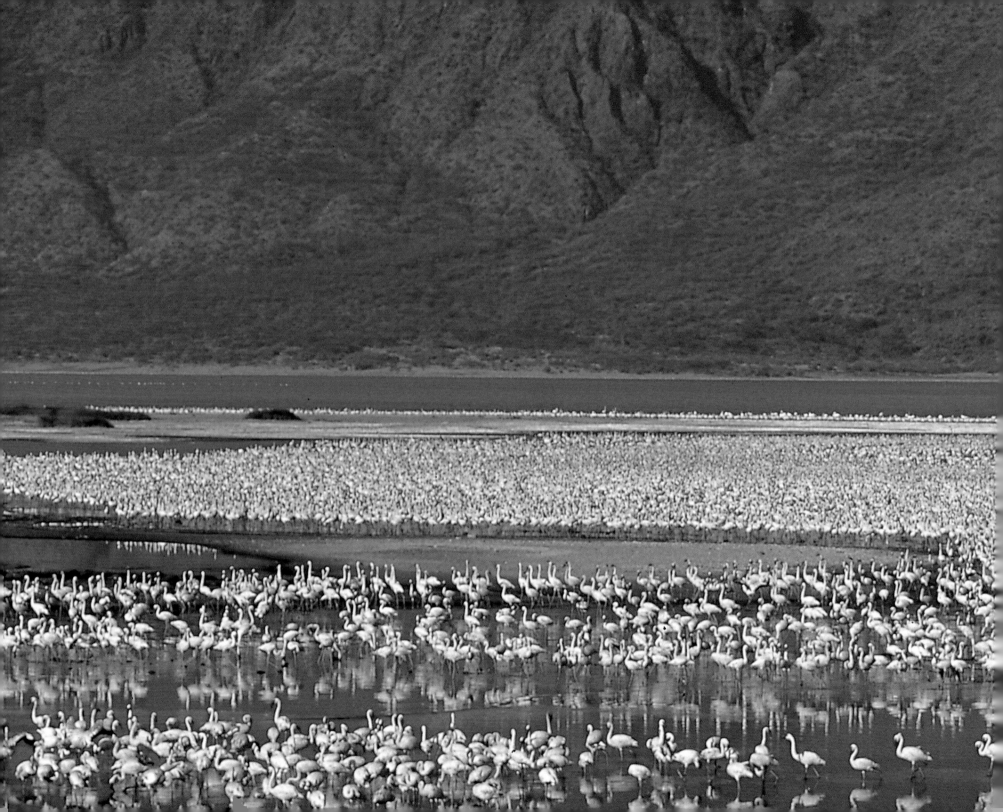

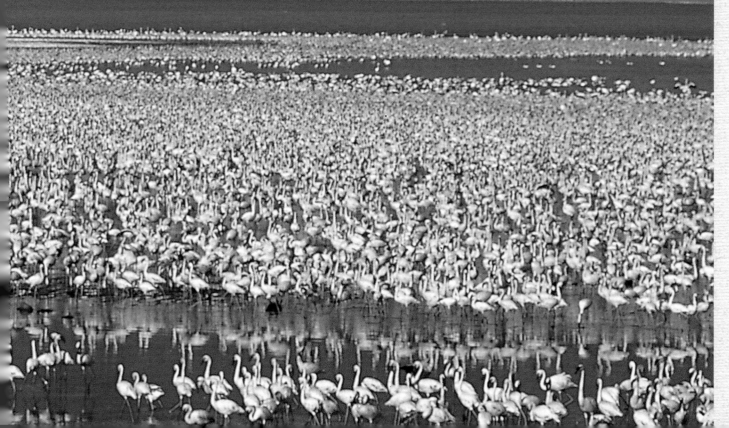

Left: Up to a million flamingos can congregate at Lake Bogoria in Kenya, representing the largest biomass of birds per unit area of any inland water body in the world.

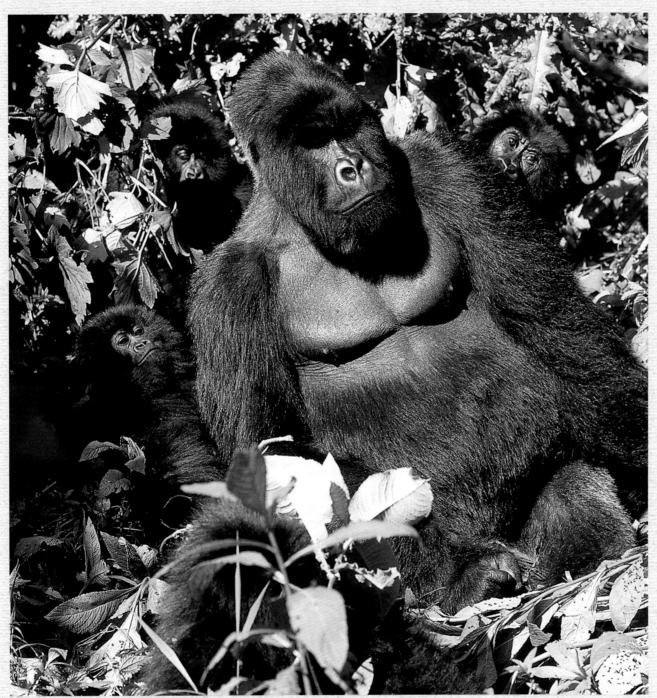

Left: A trio of mountain gorillas huddle behind the reassuring bulk of a male silverback.

Opposite: The range of the chimpanzee is now much reduced, but it can still be seen in East Africa at the Ngamba Island sanctuary, Lake Victoria, Uganda.

Overleaf: The mountain gorilla, gentle vegetarian giant of the forests, has one of its last strongholds on the slopes of the Virunga volcanoes where the borders of Zaire, Rwanda, and Uganda meet.

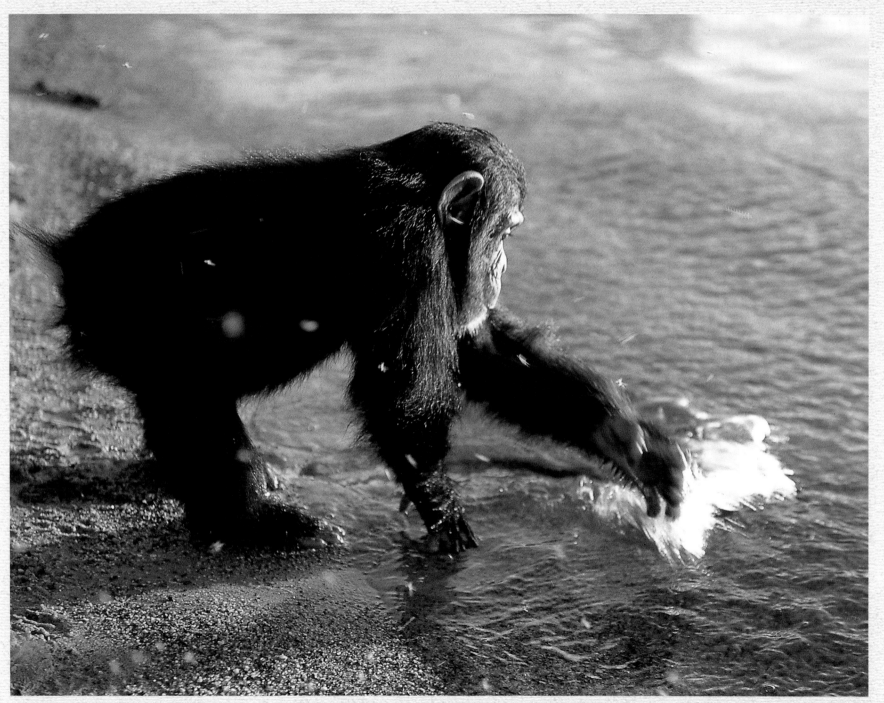

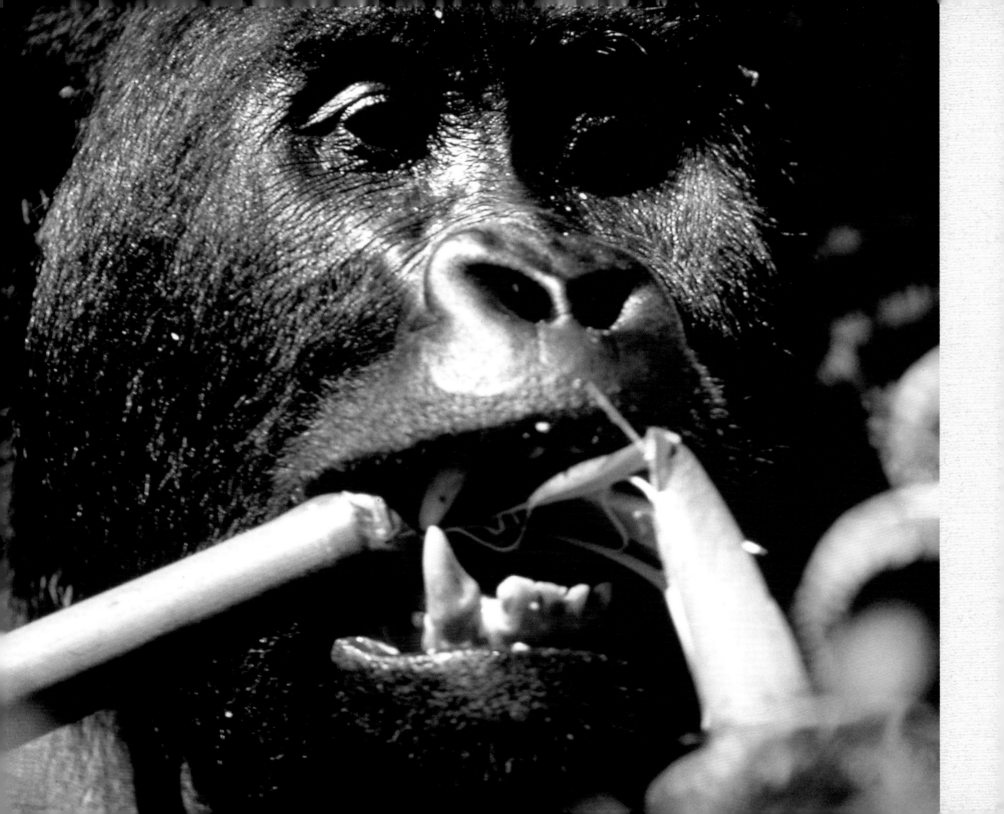

• Dining Out •

The spider weaving its seductive web, the antelope creeping warily towards a waterhole, the jackal grabbing a morsel of meat from under the nose of the lion. The multifaceted battle for survival fought out in the wilds of East Africa, and throughout the planet, is centred on the simplest requirements – food and drink.

The primary source of nutrition is the lush plant life which characterizes and defines the wide range of habitats in the region – the swaying grasses dotted with elegant acacias, the forbidding thorn scrub, the cool riverine forests. These diverse plant communities support a vast population of herbivores, and there are few more inspiring sights than the teeming herds that find their home, and their food source, on the rolling grasslands found in such havens as the Maasai Mara National Reserve.

There is a loose distinction in the herbivore population between grazers (which eat grasses at ground level) and browsers (which prefer bushes and trees). The difference between the two is highlighted by the rhino family. The white rhino's name is a corruption of the Afrikaans 'weit', meaning 'wide', referring to the broad mouth that marks it as a pure grazer (possibly the largest that has ever lived). The black rhino, on the other hand, uses its triangular hooked upper lip to browse, grasping and tearing the leaves and twigs which form the bulk of its diet.

Numbered among the grazers are zebra and most of the antelopes, including the ubiquitous impala and gazelles. The seasonal nature of the climate can take some animals long distances in search of fresh grazing, as witnessed by the spectacular annual migration of wildebeest and topi through the Serengeti-Mara ecosystem.

Some browsers are highly specialized: the lanky giraffe uses its prehensile tongue to delicately remove acacia leaves from their thorny defence shield, and the gerenuk is a sleek long-necked antelope which can stand on its hind legs to reach leaves 2 metres above the ground.

Often, though, there is no hard and fast line between the browser and the grazer, and many herbivores adapt their diet to the food available. The elephant, for example, is capable of yanking whole branches off acacia trees and consuming them thorns and all, yet a large proportion of its diet is grasses. Two hundred kilograms of fodder per day is hard to come by unless you're prepared to be a little flexible!

The interrelationship between the animal and plant kingdoms of the savannah is complex and not yet completely understood. Elephants play an important role, and can clear woodland if their population burgeons. Impala maintain grassland by eating acacia shoots. The balance is essentially dynamic and unstable, with vegetation boundaries constantly shifting with the ebb and flow of animal populations.

The carnivores, meanwhile, smack their lips as the wonderful process of life converts vegetable matter into the walking meat that fills their larder. The big cats top the food chain, and again each has its own particular niche. The leopard hunts secretly and alone, usually by night. The cheetah uses a spectacular burst of speed to down fleeing antelope. But the lord of them all is surely the lion, which uses sophisticated teamwork to hunt down prey as impressive as the buffalo.

Even then this is not the end of the story, for once the big cats have had their fill the scavengers come. Yelping hyenas and cautiously slinking jackals will eventually drive the bloated lions off their prey, and vultures will swoop out of the sky to polish off whatever remains. Beware of stereotyping, though – many a hyena has been driven off of its own hard-won kill by scavenging lion.

It is interesting to reflect that although the feeding requirements of the animals of the African bush are incredibly diverse, they all share a need for one basic commodity – water. And so, as darkness falls, the waterholes become tense hubs of activity as animals that might normally be in conflict make their wary way towards a situation that is vital to their very existence, but might conceivably end in their death. The tiny dik-dik has the answer – it can survive on the water content of the vegetation it eats.

But let us not forget, as we are transfixed by the main actors in the drama of the plains, the cast of millions that play bit parts on Africa's vast stage: a myriad of termites and spiders and butterflies, the scurrying rodents that consume them, the brightly plumaged birds that pluck them out of the air. From the smallest beetle to the largest elephant, all consume and will, ultimately, be consumed.

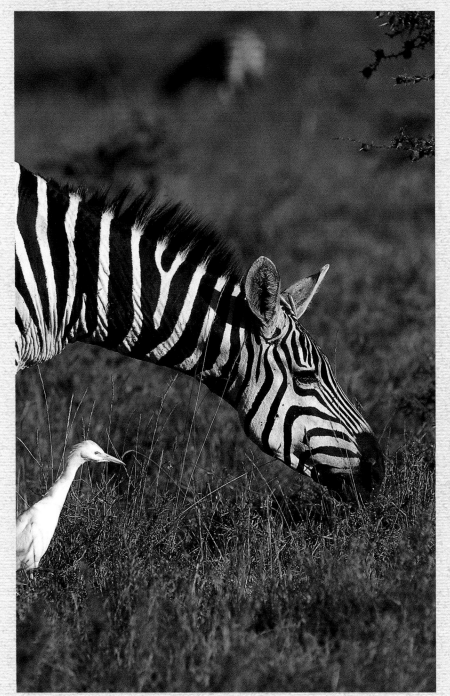

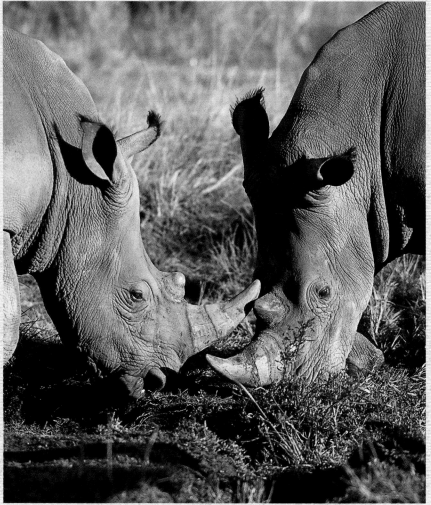

Left: Common or Burchell's zebra grazing, cattle egret in attendance ready to snap up any disturbed insects.

Above: The huge white rhino has a wide, square mouth adapted to grazing, unlike its hook-lipped, browsing black cousin.

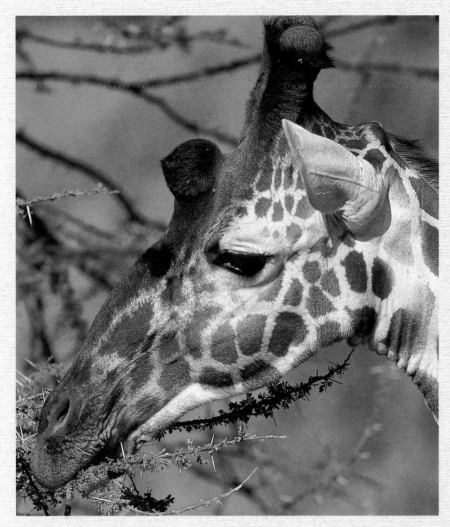

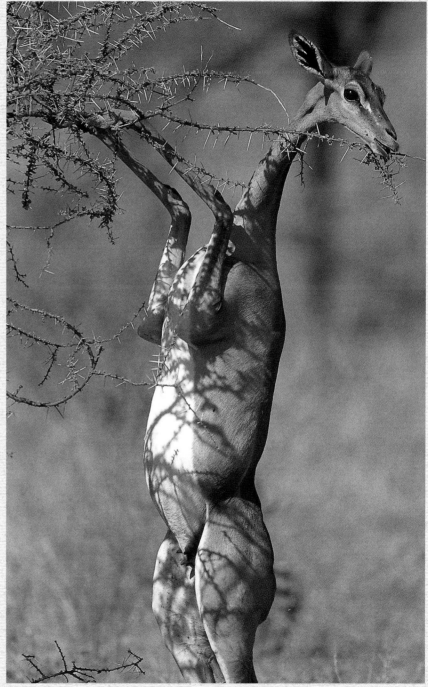

Above: A browsing giraffe gingerly removes acacia leaves from their thorny defences.

Right: In Samburu, a gerenuk uses its remarkable combination of extended neck, long legs, and upright stance to reach acacia leaves up to two metres above the ground.

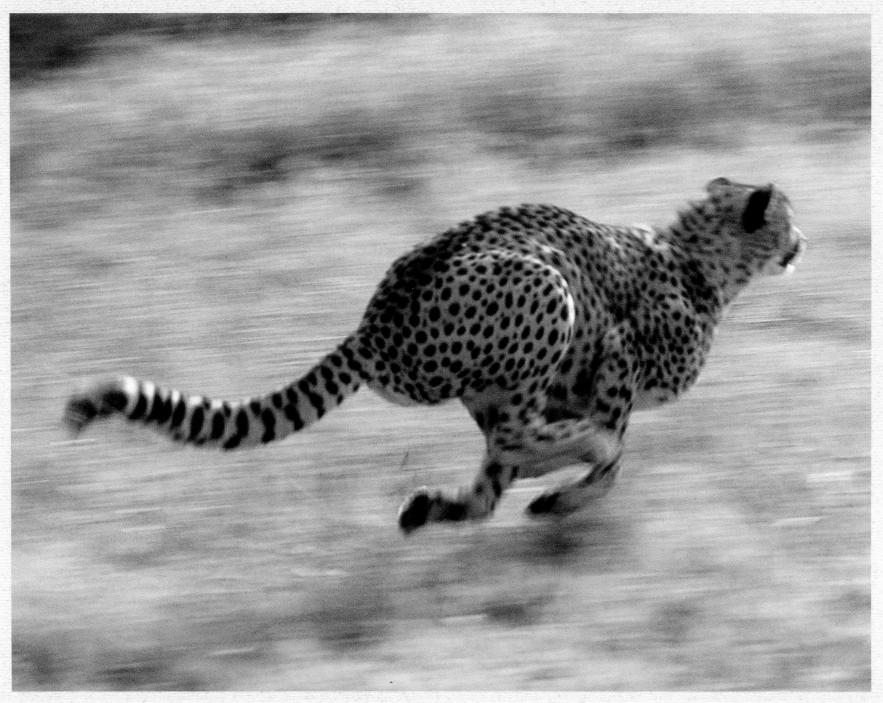

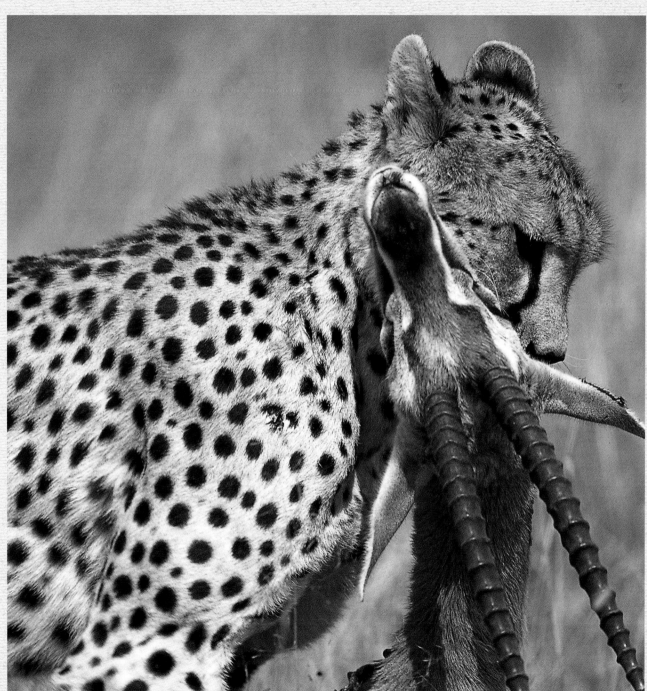

Opposite: One of the most awe-inspiring sights in nature, a cheetah in full flight. It can achieve speeds of over 100 kilometres per hour as it chases down its antelope prey.

Right: The cheetah will drag this Thomson's gazelle into cover as soon as it can; it is no match for any lion or hyena intent on relieving it of its kill.

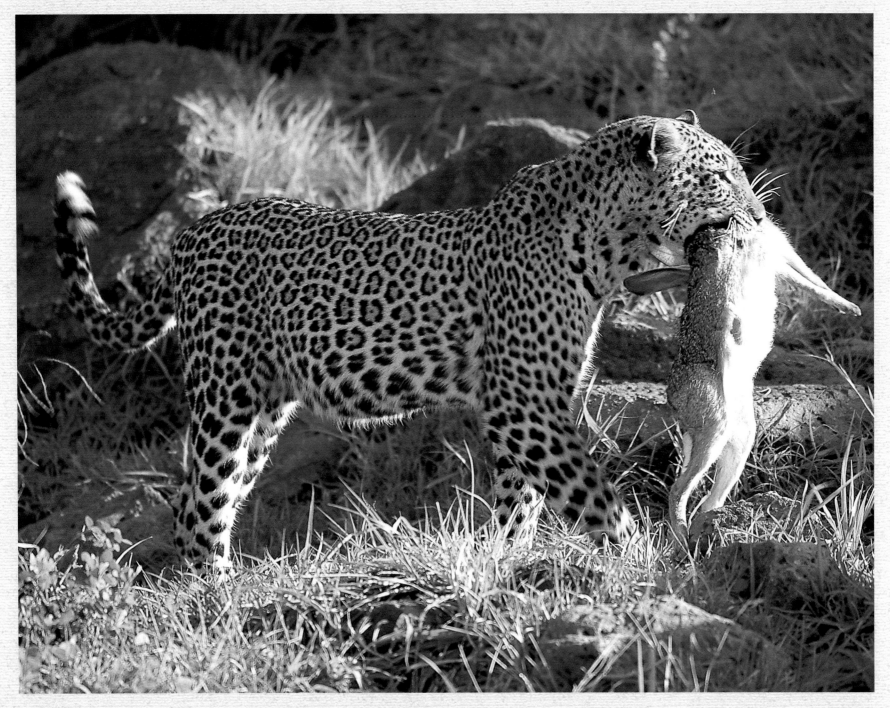

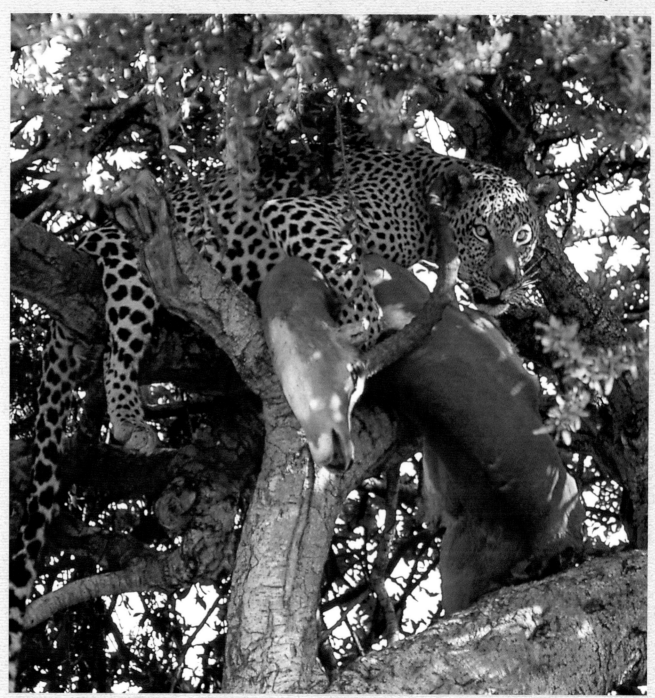

Opposite: The nocturnal and secretive leopard has a wide and varied diet, including this African hare caught in the Maasai Mara.

Right: The leopard possesses prodigious strength for its size; it is capable of hauling a full-grown male impala up a tree, safe from other predators.

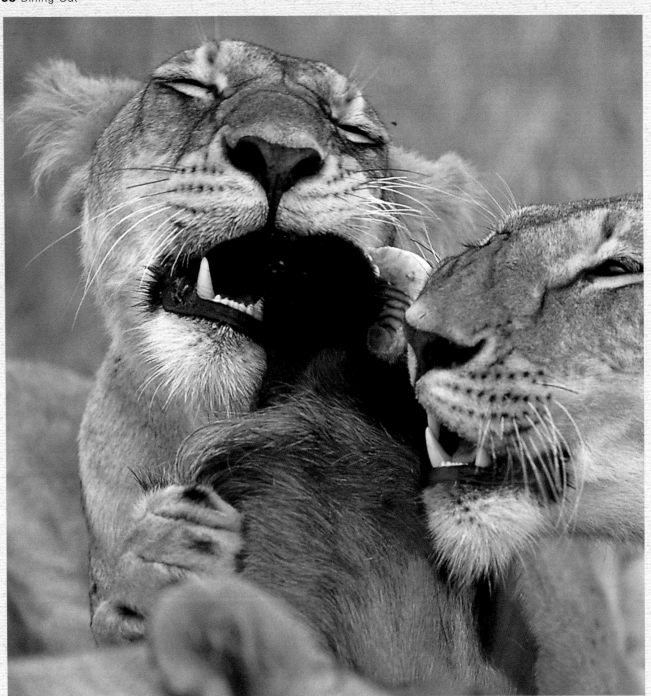

Left: The lion is the most social of the big cats. Most of the hunting is done by the females; here, their reward is a wildebeest.

Opposite: A wary hyena places a proprietary paw on its intended dinner while an audience of vultures await their turn.

Following pages: There is enough meat on this giraffe for hyena and lion to tolerate each other's presence at the carcass.

A white-backed vulture alights on a wildebeest that failed to survive the migratory crossing of the Mara River.

A silver-backed jackal cowers as lappet-faced and white-backed vultures attempt to persuade it to abandon its meal.

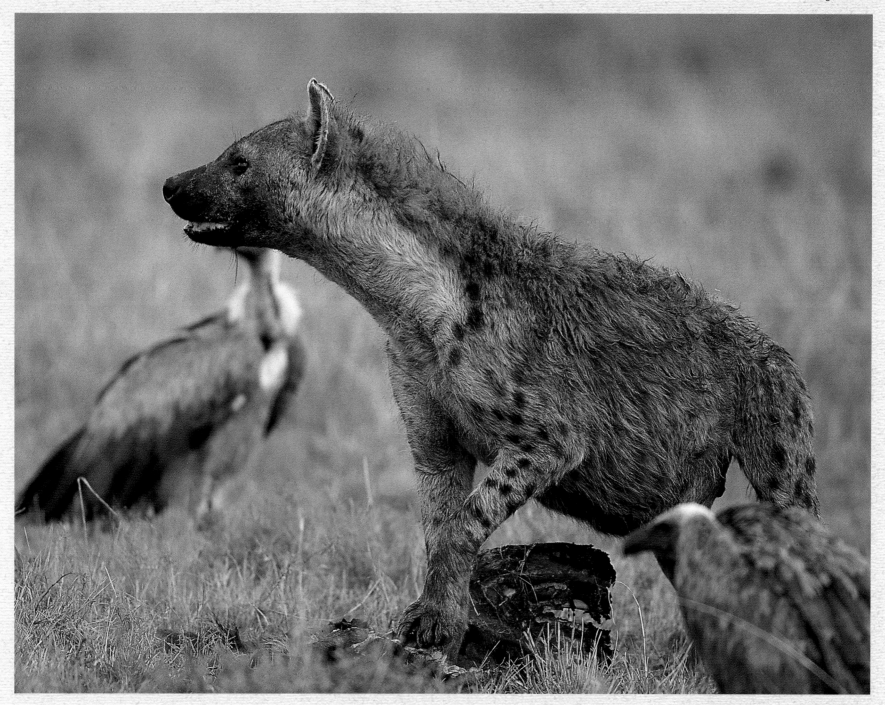

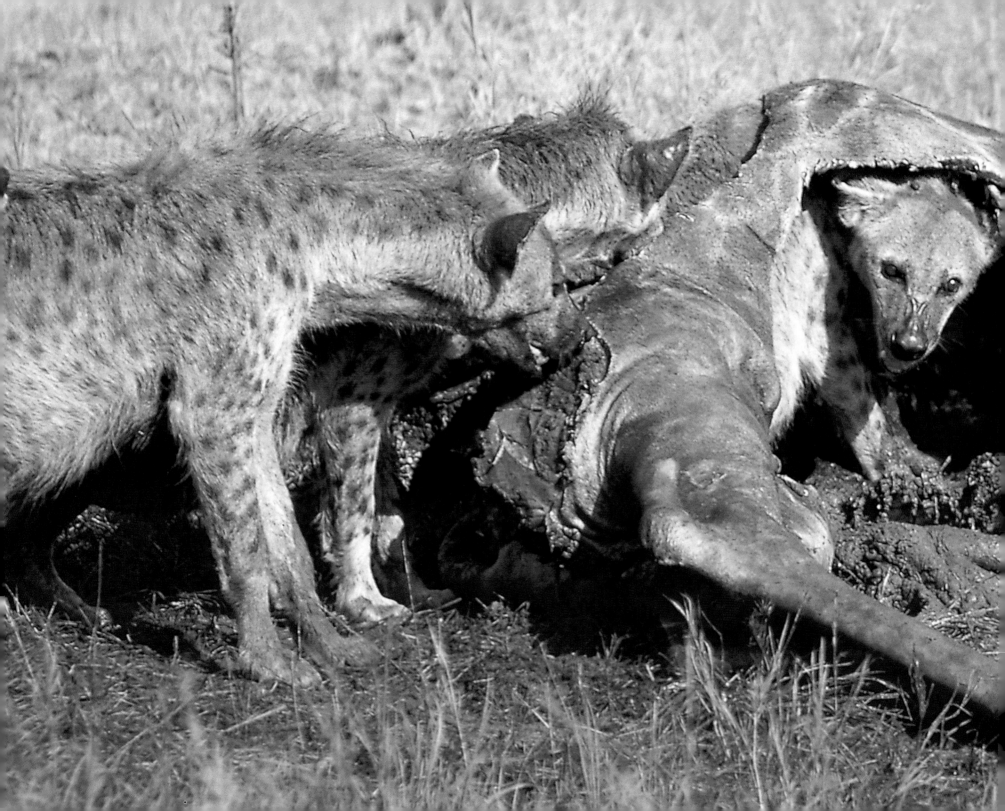

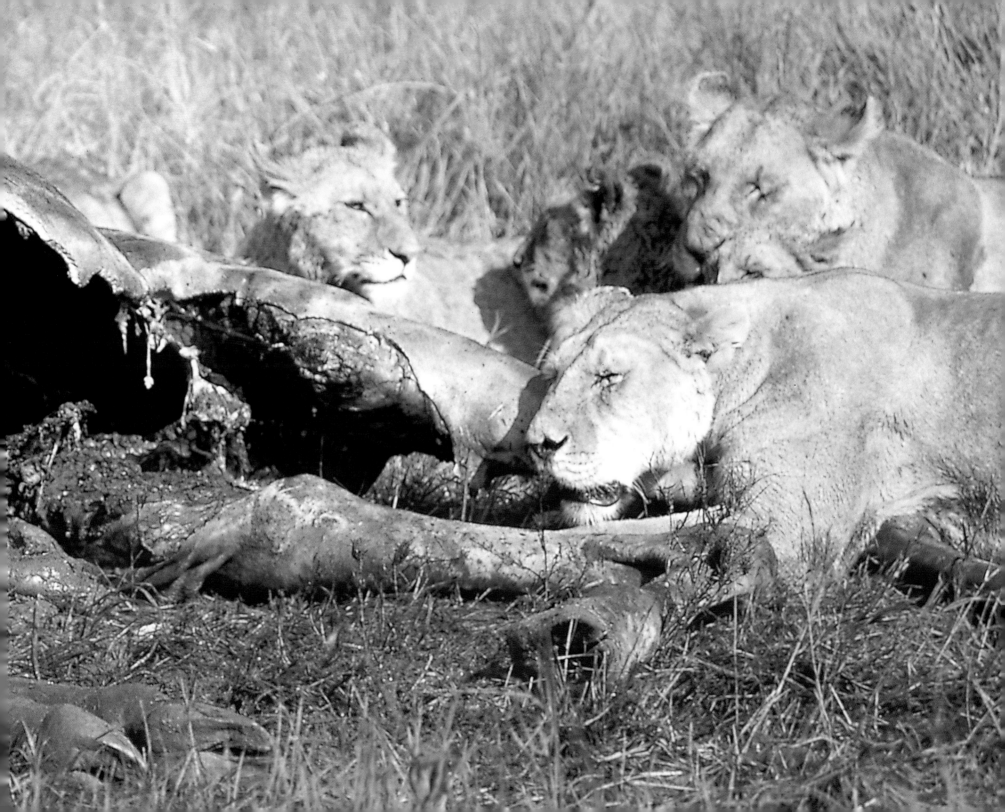

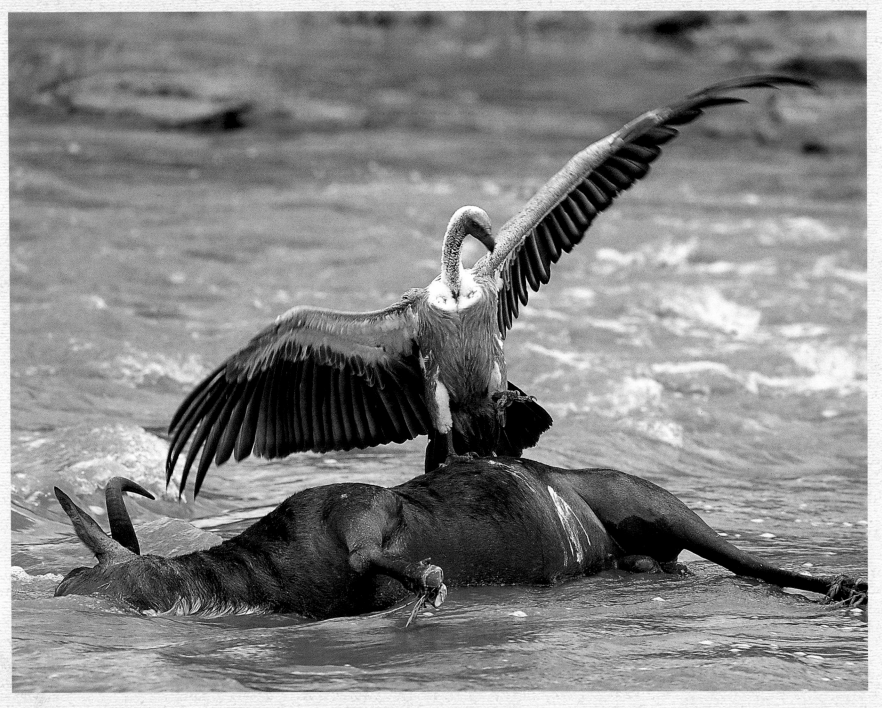

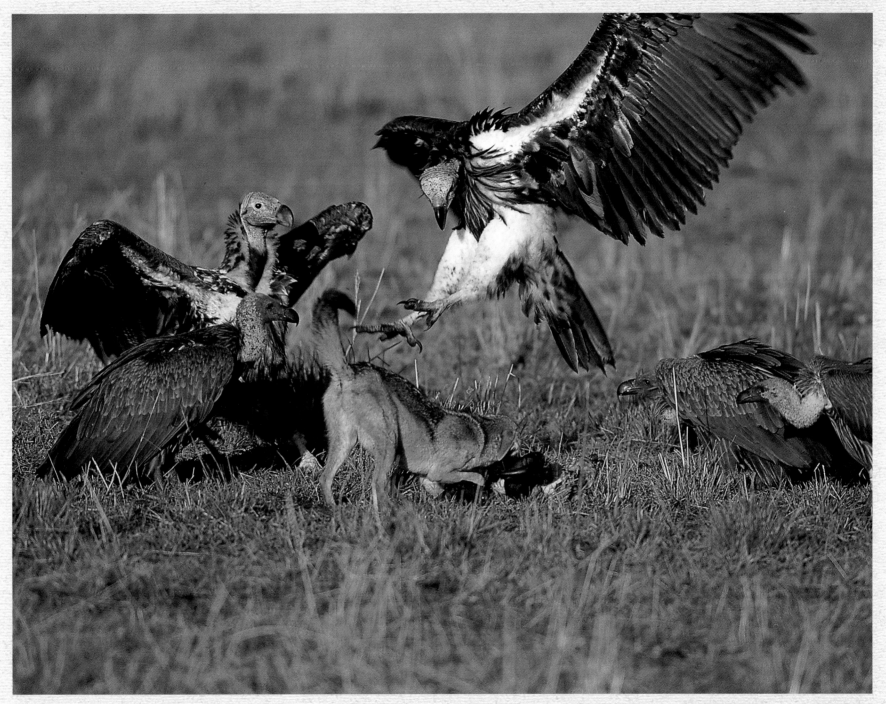

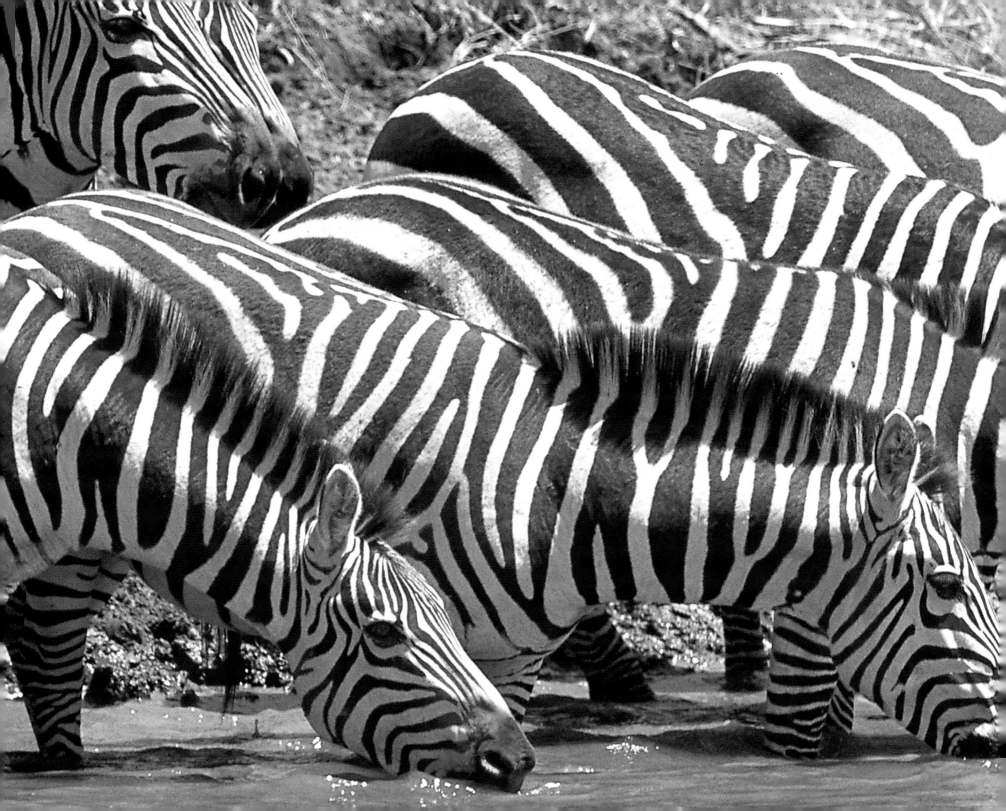

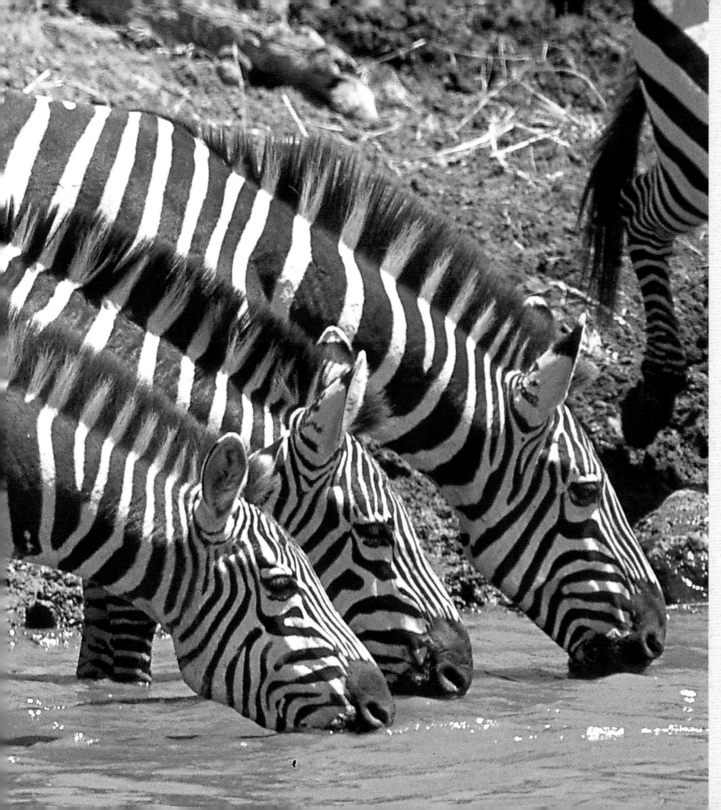

Left: A line of zebra slake their thirst at a river, but danger lurks . . .

Following pages: In a frenzy of feeding activity, Mara River crocodiles demolish a zebra unfortunate enough to stray too close. The crocodile cannot chew; instead, it clamps its jaws on its victim's body and spins to tear off chunks of flesh.

A python enfolds a Thomson's gazelle in a deadly embrace as it embarks on the long process of swallowing it head first.

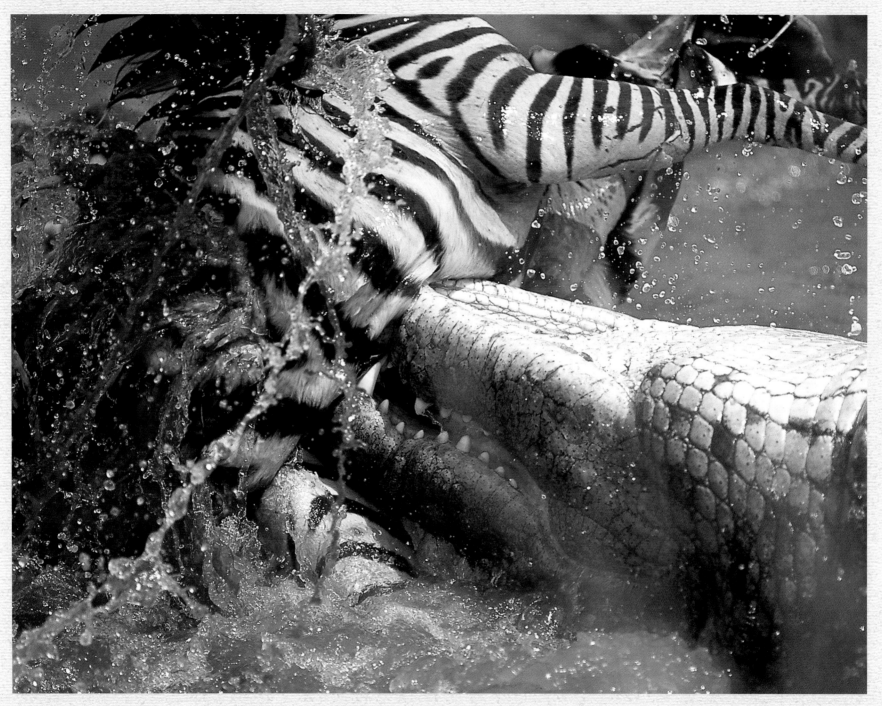

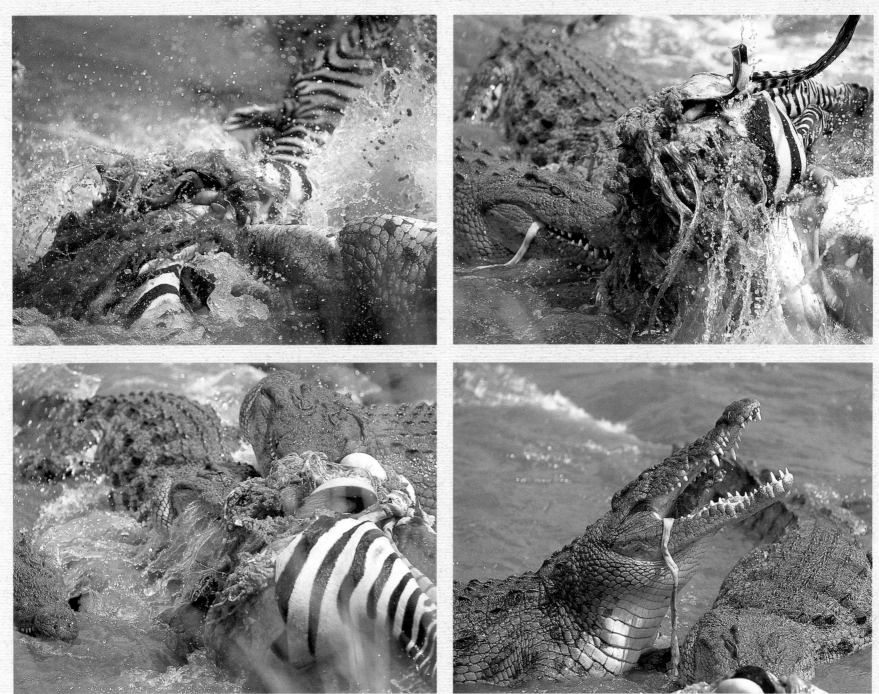

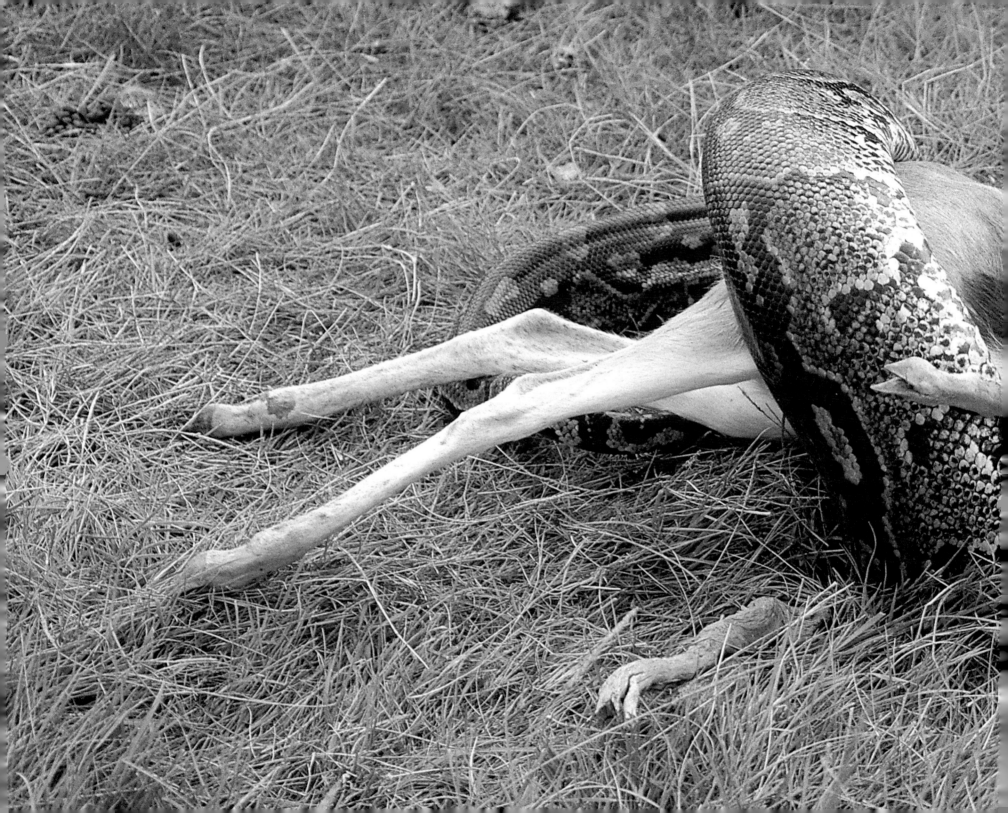

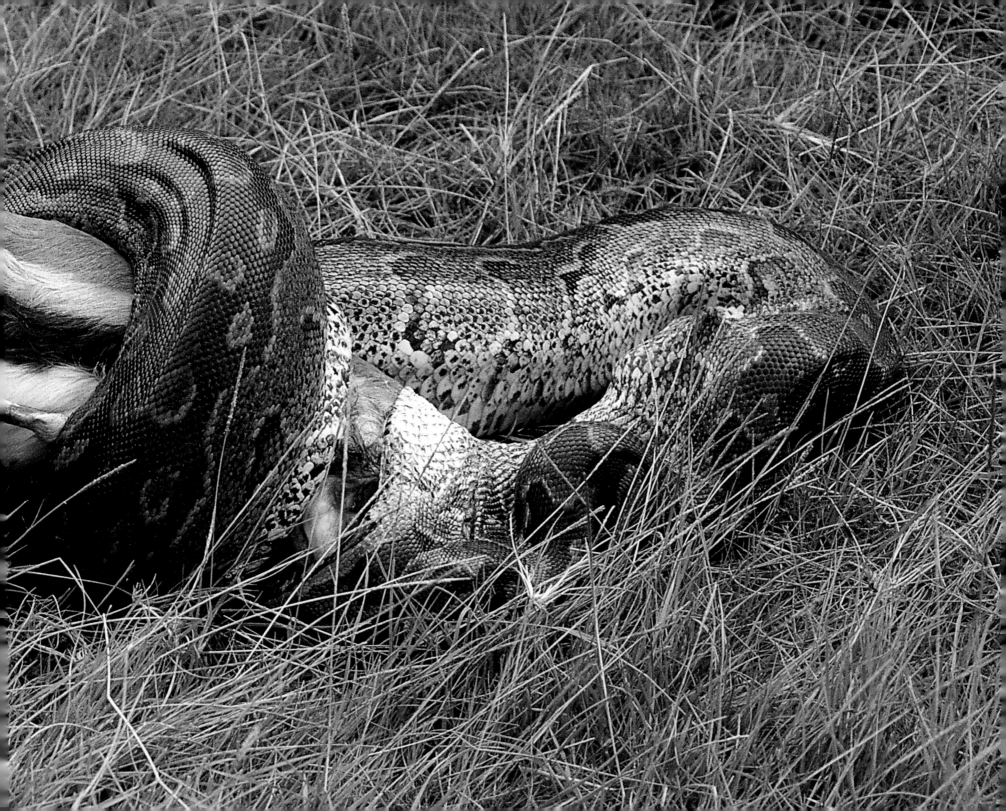

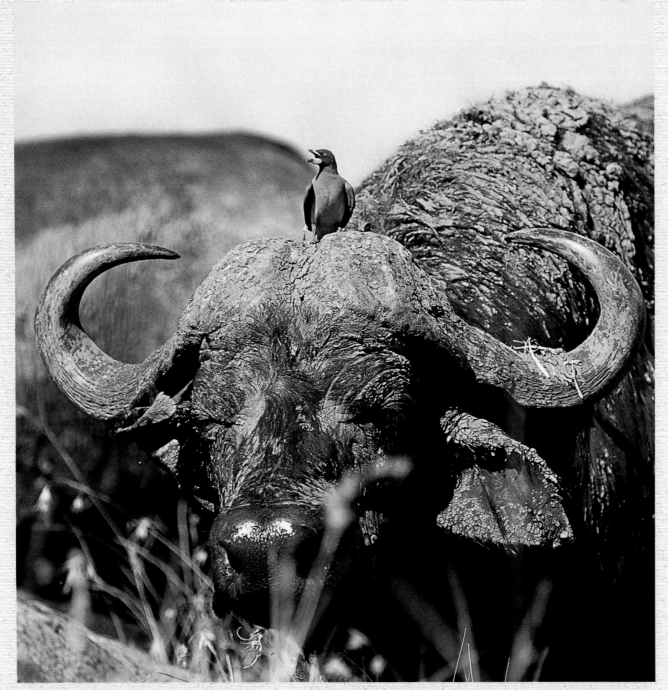

Left: Beauty and the beast: a mud-caked buffalo dries out in the sun, serenaded by a yellow-billed oxpecker.

Opposite, left: A saddle-billed stork finds a tasty dish in the swamps of Amboseli, southern Kenya.

Opposite, right: A frog contemplates its last seconds of existence in the beak of a malachite kingfisher.

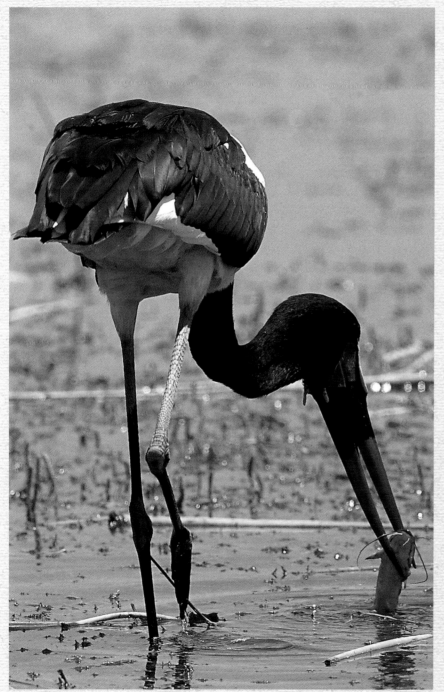

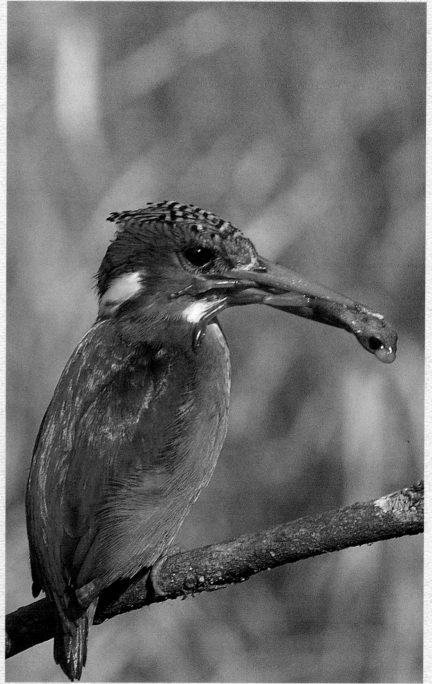

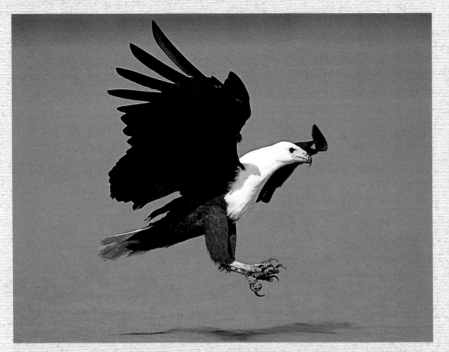
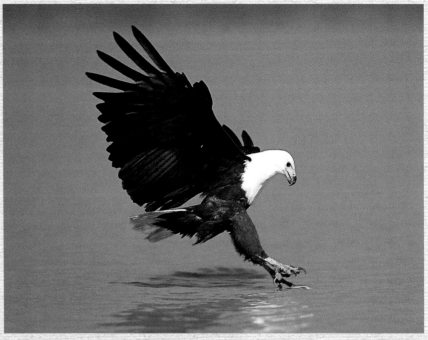
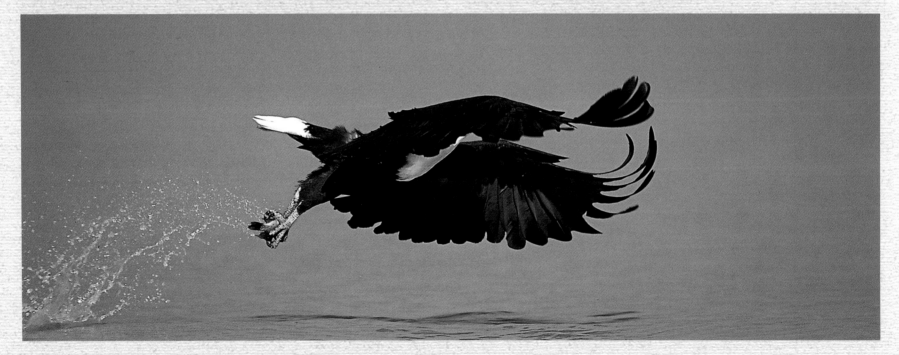

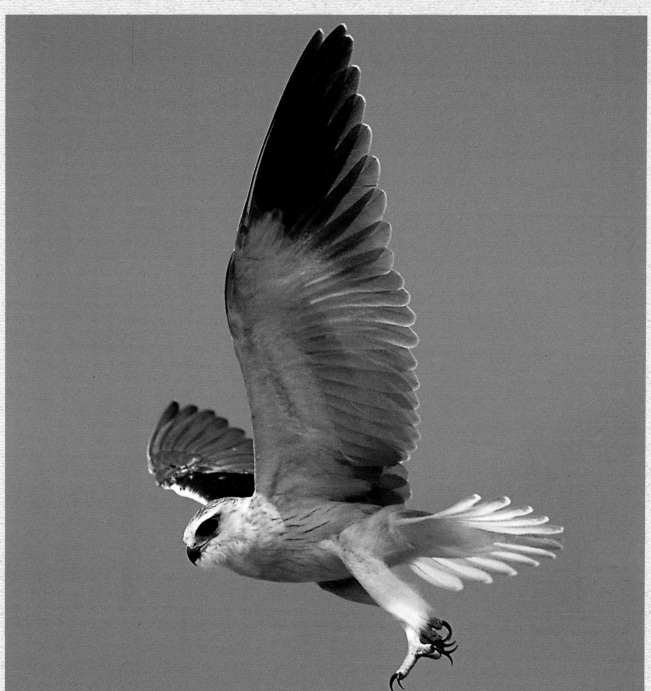

Opposite: A fish eagle demonstrates its impressive fishing skills at Lake Baringo, Kenya. The far-carrying, haunting cry of the fish eagle is one of the most evocative sounds of wild Africa.

Right: The delicate black-shouldered kite hovers above the bush, its sharp eyes scanning the ground for rodents and other prey.

Overleaf: Life doesn't get any better! A family of hippopotamus wallowing in the shallows. The hippo leads a double life: solitary when foraging on land during the night, it rests and digests in gregarious congregations in the water by day.

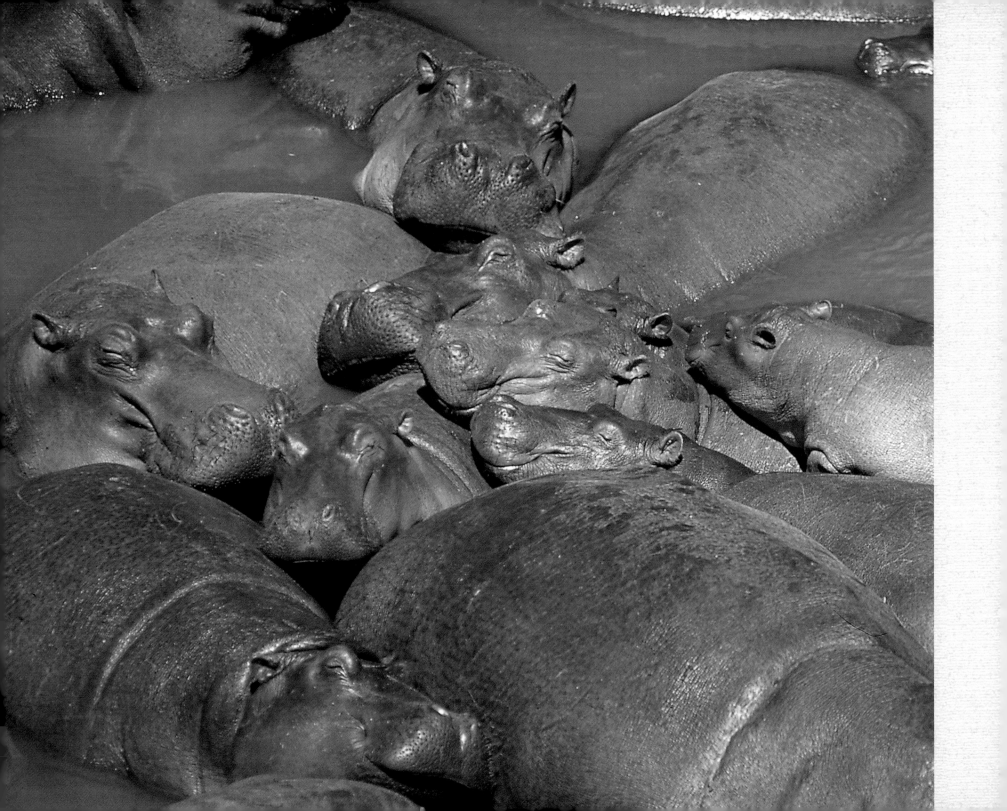

• At Rest and Play •

This is surely the highlight of your safari. Slowly you scan the bush from your vehicle, and suddenly there they are – a pride of lions! A few dominant males, several females, and probably a number of small cubs. Even better if you happen to see them in action, but the chances are they've already eaten, thank you very much (the well-chewed carcass may well be nearby), and will now be doing what they do best – resting.

It is easy to forget that this period of rest is as crucial to the lion's existence as the hunt that produced the earlier repast. Looking at their bloated stomachs, one reason for their current inactivity is plain. They have gorged themselves on meat, and need time to digest it. At this moment the game around the pride is well aware that it is under no threat, and will not waste effort fleeing an already sated hunter.

And so rest conserves vital energy. As night approaches, the very survival of the hunter and the hunted will depend on their ability to outrun one another, to find that last inch of speed to shake off a pursuer, or that last ounce of strength to drag a larger animal to the ground.

But now, as the harsh overhead sun reaches its apex in the middle of the African day, there is peace in the bush, as lion and impala alike find whatever shade they can and relax. If ever the lion is going to lie down with the lamb, it is now.

There are, however, necessary tasks to be performed during these tranquil hours. Grooming and preening are carried out to keep the animal's important outer layer in good condition, and to remove parasites such as ticks that might threaten its health. You can do this yourself, or get someone else to do it – even the crocodile will resist the temptation to scoff the egret which steps daintily inside its gaping maw to clean its teeth of tiresome morsels.

Among gregarious animals grooming also has a social function, helping to establish and confirm the dominance hierarchy that is essential to the stability of the group and has a bearing on so many facets of its existence, including access to food and to mating partners. If this process can occur through grooming rather than fighting, then so much the better. And so the dominant baboons in the troop will lie back and expect their subordinates to rummage through their fur for irritating fleas and ticks. Play, too, can help the youngsters in a group to establish their position in the pecking order; even at an early age certain individuals will rule the roost in play fights.

Play also helps animals rehearse the skills that will boost their chances of survival in later life. Through exploration of their environment mongoose offspring will soon learn the surest and quickest route to safety. Young antelope run and leap, or engage in mock combat. And lions, in their play, practise the techniques that will be put to more deadly use when they are old enough to join the hunt, or, in the case of the males, when they attain the strength and maturity to take over their own pride. Such is the vital role of play that it is not just a prerogative of the young – lions remain playful all their lives, and adults and youngsters will frequently romp together.

As with humans, animal play is often simply a matter of learning to use the body to its full potential. If you're an elephant, for example, and your trunk contains 15,000 muscles, then learning to use it effectively can take a little practice.

It is all very well, of course, explaining rest and play in functional terms, but anyone who has seen baby rhino frolicking in the bush, or buffalo wallowing in a waterhole, cannot deny that there are times when animals simply have fun!

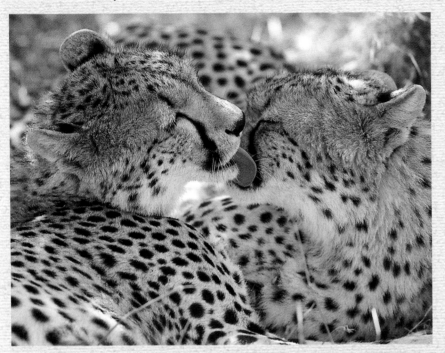

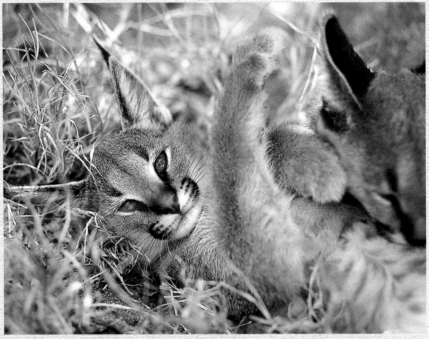

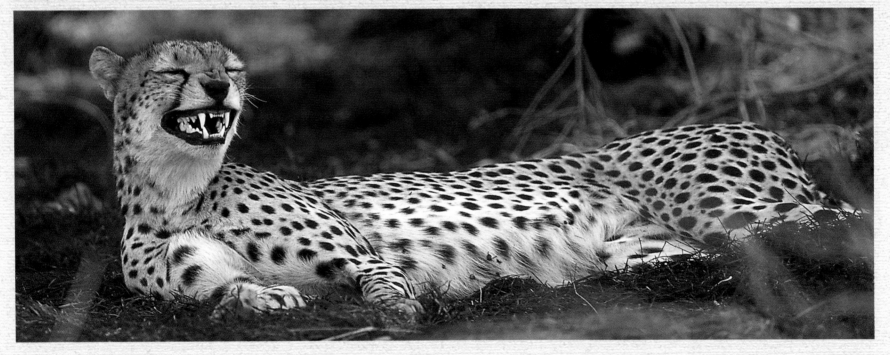

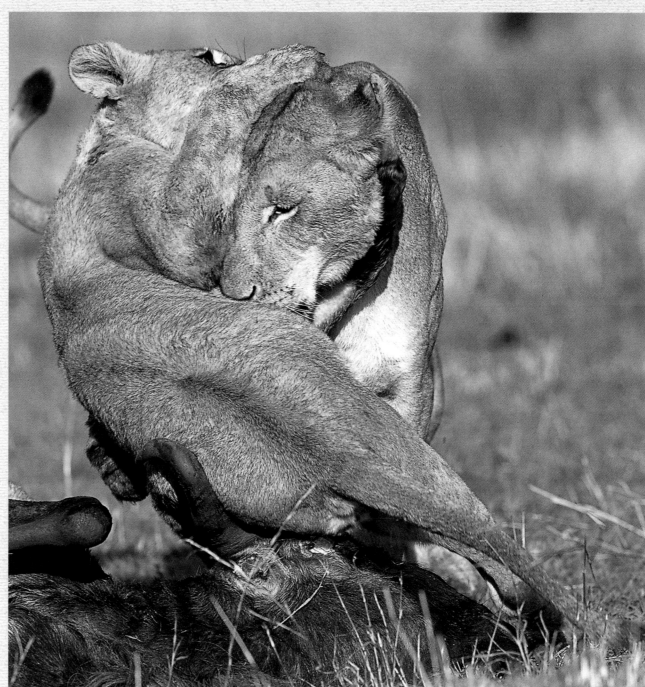

Opposite, above left: A group of cheetah seen together will often be a mother with sub-adult cubs. This inoffensive cat has never been known to kill a human.

Opposite, above right: Now, the caracal relaxes; in a few hours it will be an agile hunter capable of clawing birds out of mid-air.

Opposite: There is no mistaking the pleasure in the grin of this reposing cheetah.

Right. Even while they are eating, these lions cement their position in the hierarchy with a bout of play wrestling.

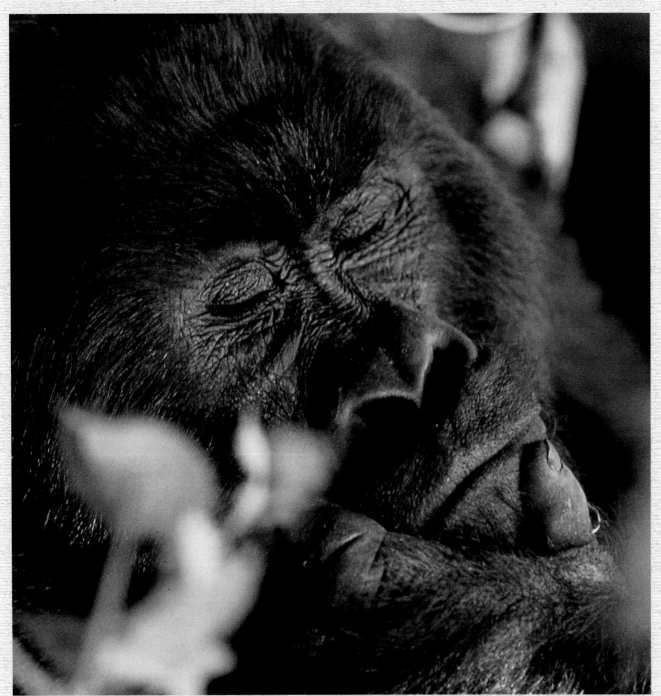

Left: A mountain gorilla slumbers pensively amid thick foliage.

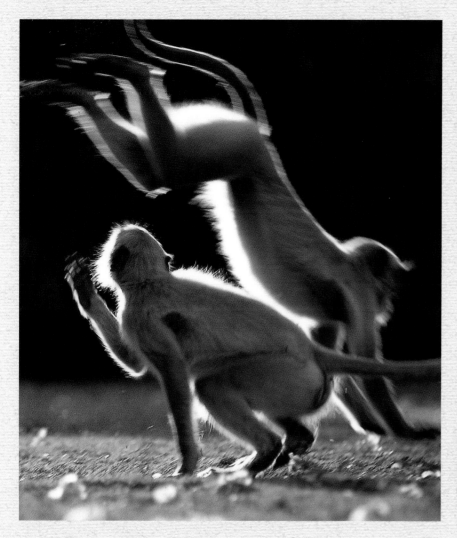

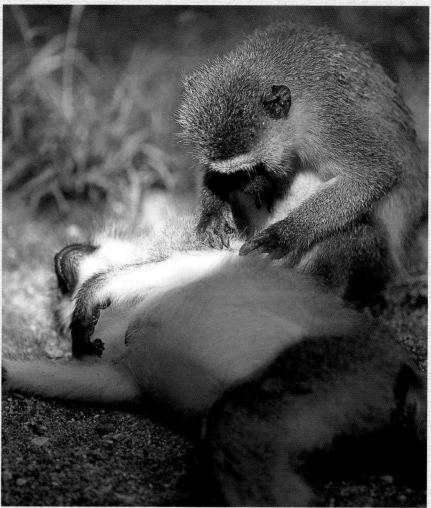

Above: Mischievous vervet monkeys in tumbling play. The vervet is the most wide-spread monkey of the African savannah, and is a quick-witted and opportunistic omnivore.

Above: Vervet monkeys, Samburu. Grooming is an important element of social interaction between vervets; as well as helping keep the animal free of parasites, it strengthens kinship bonds.

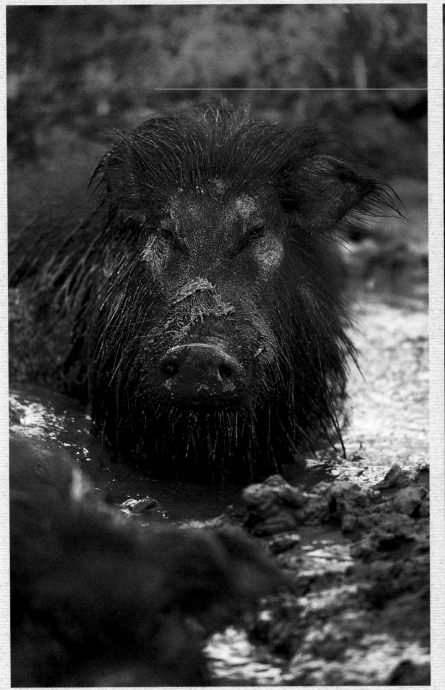

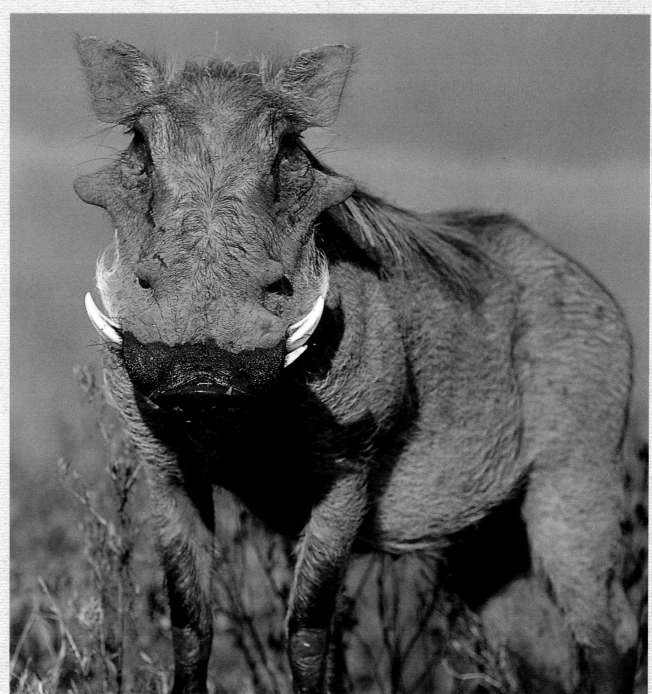

Opposite: A giant forest hog (Queen Elizabeth National Park, Uganda) enjoys a waterhole wallow for relief from the heat and from biting insects. Despite their size – they weigh up to 230 kg – these creatures are elusive, inhabiting dense cover and only moving into the open to graze after dusk.

Right: The warthog, the only pig species to graze the open savannah, is often drawn to a waterhole during the heat of the day.

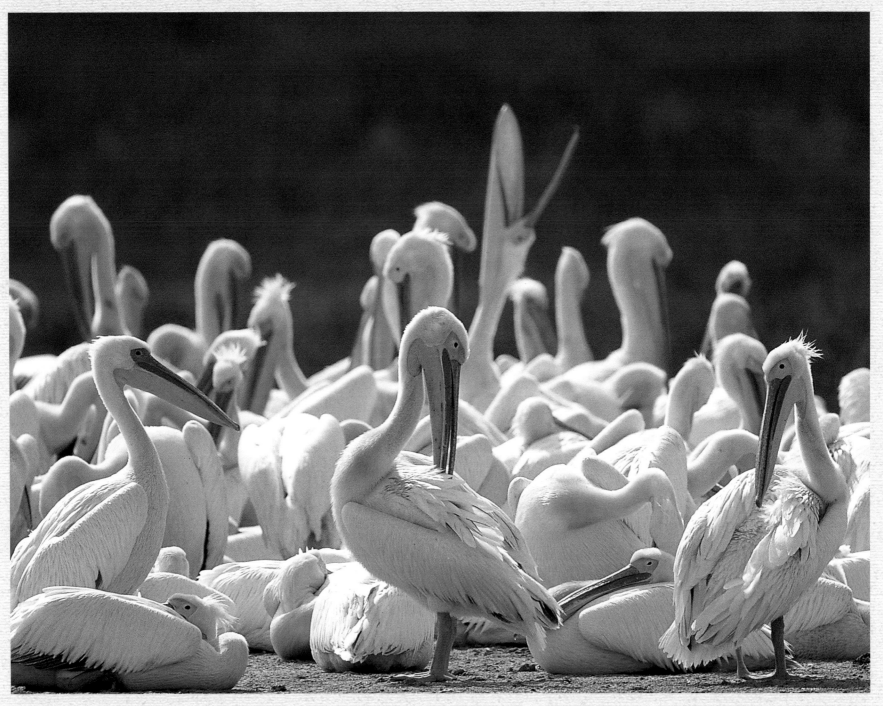

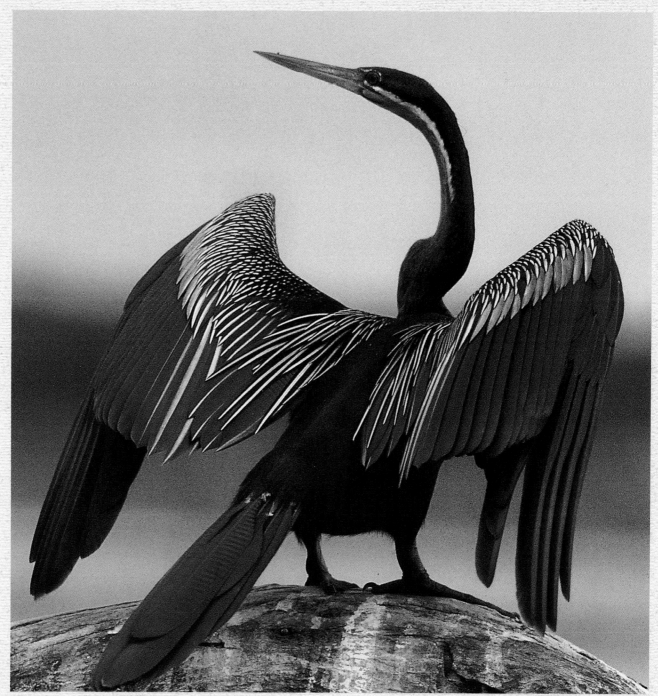

Opposite: A flock of great white pelicans at rest, some preening their feathers to maintain the condition of their plumage.

Right: Unusual among fishing birds, the darter lacks oil glands with which to preen, and must spread its wings in the sun to dry them.

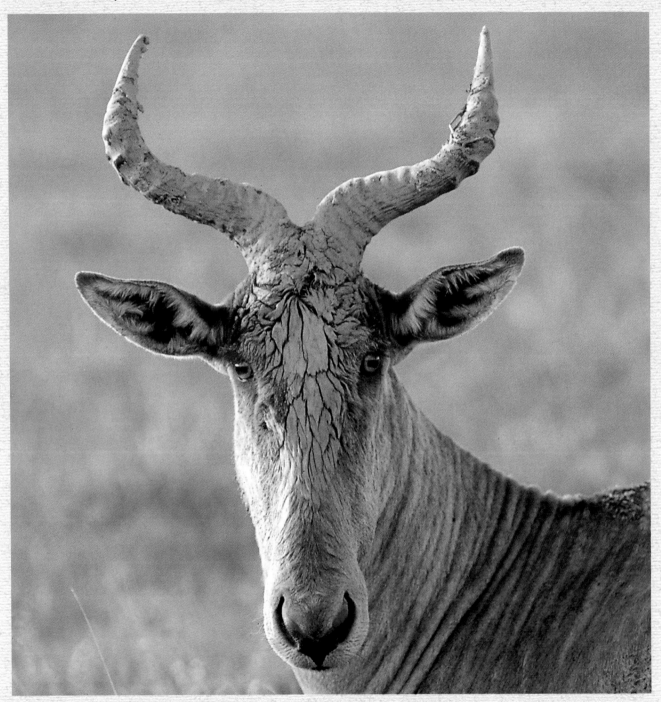

Left: The mud-encrusted face and horns of a kongoni.

Opposite: Even at rest the ears of this female impala are pricked, alert for any threats.

Overleaf: A Grant's gazelle shows maternal concern for her newborn kid.

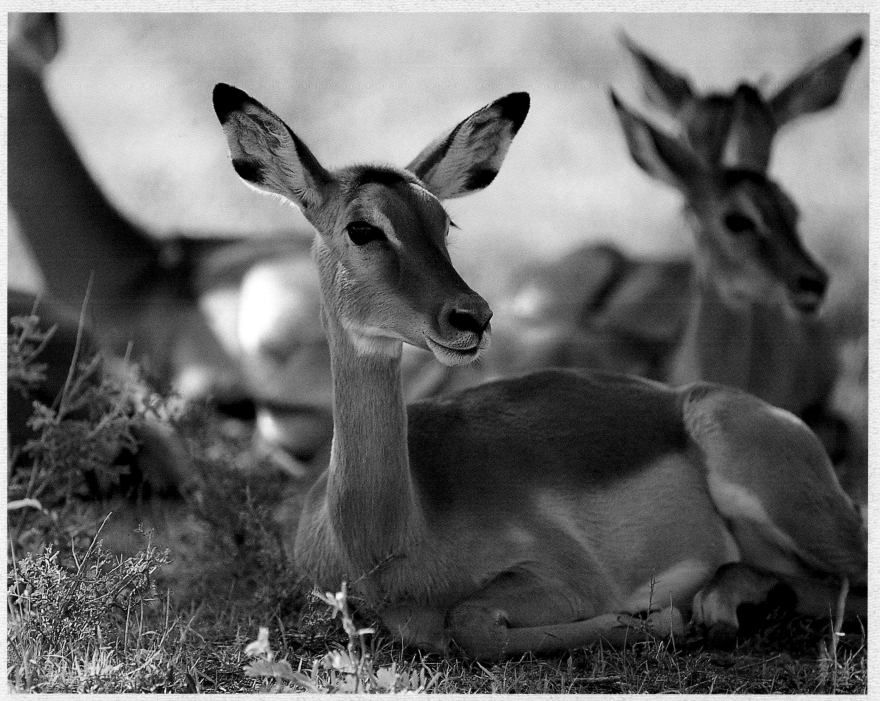

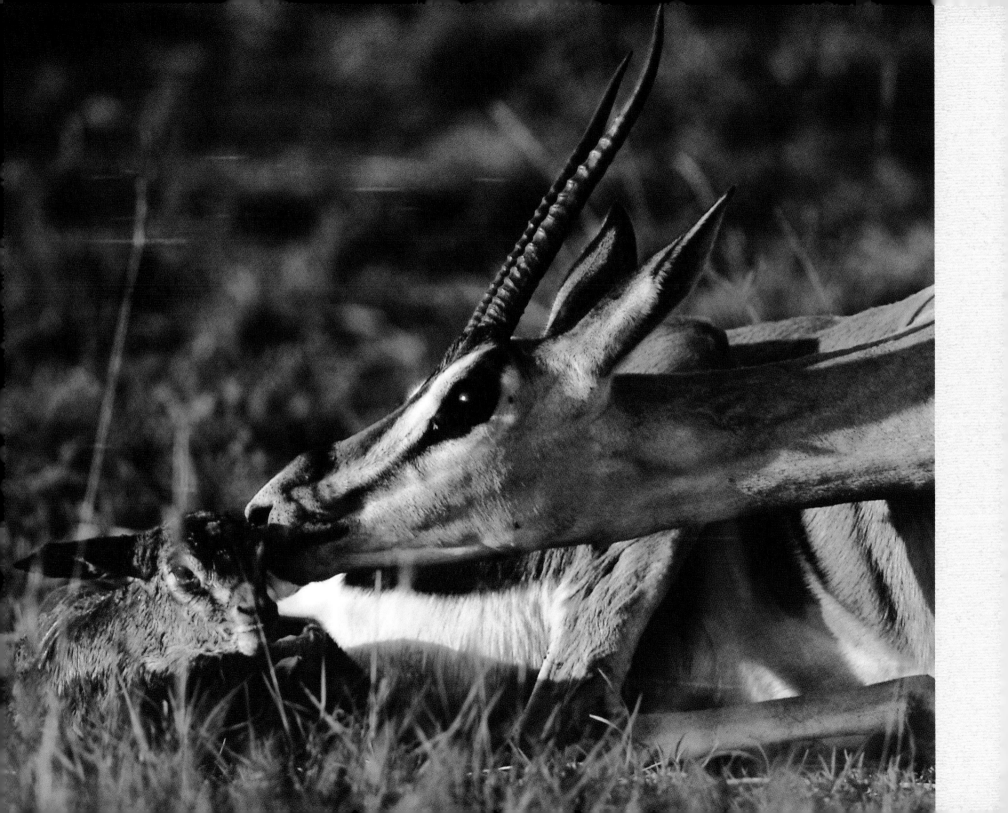

• The Eternal Cycle •

Birth, life, death – the never-ending cycle of generation and regeneration through which species pass on their genes and attempt to ensure their continued survival. Each stage is driven by powerful basic instincts which manifest themselves in a vast variety of social interactions.

First, find your mate. Often the pairing takes place after intense competition among rival males, which may already have involved a long period of social jostling for position. In baboon society, for example, the high-ranking males are much more likely to find mating opportunities.

Perhaps the most bloodthirsty rivalry occurs amongst lions. Young males driven from their home pride will eventually take over another pride, evicting the incumbent males and sometimes killing any cubs present to enhance their own gene line. The final choice in the matter, however, lies with the female; a lioness in oestrus approaches the male she has selected, tail in air to announce her availability.

In some species courtship and mating are closely associated with territorial dominance. A male impala gathers a herd of females into his chosen domain and defends it with every last ounce of his strength, seeing off challengers while still finding the energy to mate. The instinct for self-preservation is strong, however, and only when all other methods of intimidation have failed will competing males indulge in shuddering horn-to-horn combat.

Such unwelcome and stamina-sapping intrusions can be discouraged by territorial marking. The diminutive dik-dik antelope deposits a scented secretion on twigs from preocular glands. Dik-dik exhibit remarkable fidelity, with a pair remaining in the same territory for life.

Most animals also use dung and urine to mark their territory. Be careful not to stand behind the rhino during this process – it squirts urine backwards over chosen bushes with a force reminiscent of a water hydrant!

The actual gestation period varies widely from animal to animal. The longest is the 21 months of the elephant, while that of the smaller mongoose species may be little more than a month. The leopard's gestation period is a surprisingly short three months, and the cubs are born blind and helpless.

In strong contrast are the young of the antelope family, whose very survival depends on a precocial ability to move with their parents soon after birth. An infant wildebeest, for example, can stand just 15 minutes after being born, and can follow its mother shortly afterwards. Wildebeest births are extremely seasonal, all occurring together in a period of two to three weeks before the rains. Staggered births would slow the migration, and the young would be more easily picked off by predators.

Youngsters that mature more slowly are highly vulnerable and require vigilant protection. The lioness will hide her cubs for some months until she deems it safe to lead them back to the pride. Lionesses will often suckle not only their own cubs but the cubs of closely related females, aiding the continuation of their shared genes.

What happens as the young grow older depends on the nature of the particular species' society. As female baboons mature they find their own niche in the hierarchy of their home troop, while the males may join several troops during the course of their lives. A lioness will generally remain in the same pride and territory throughout her life, while the young males are driven out when a few years old. A rhino calf may stay with its mother for up to four years, until she is ready to breed again.

Old age is rare in the harsh environment of the African bush. Perhaps the greatest respect for the aged occurs among the elephant. The elephant is unusual in that it keeps on growing for its entire life, and the rank it attains is governed largely by its size. Elephant society is dominated by older females, with a matriarch in overall command. These older elephant are revered for their experience and their ability to recognize whether particular situations are threatening or not.

Most species, however, will leave the weak and infirm to their own devices as the group moves on. There is little room for sentiment in the eternal cycle of life – and death.

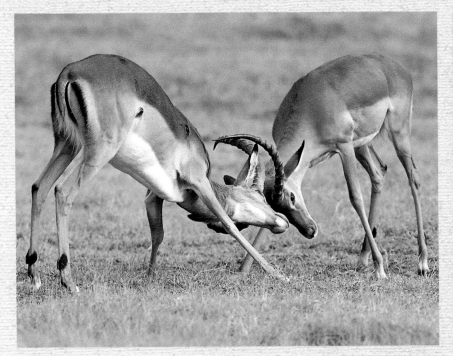

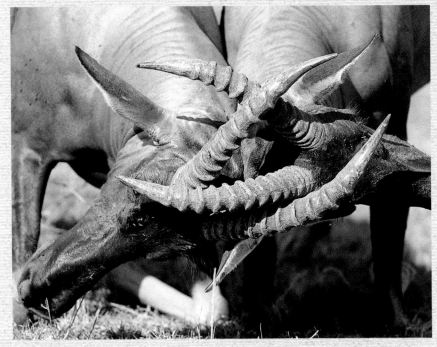

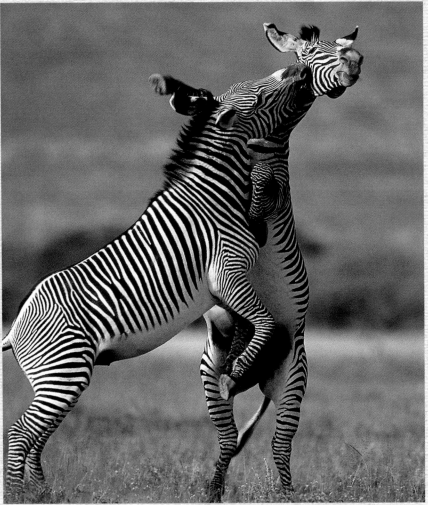

Above left: Male impala will use a variety of signals, included posturing and urine marking, to warn other males out of their territory. If all else fails horn-to-horn combat will decide the issue.

Left: The distinctive indigo markings of the topi can be seen in these sparring males in the Maasai Mara.

Above: Neck biting is one of the intimidatory techniques employed by fighting Grevy's zebra.

Opposite: Male beisa oryx battle for supremacy in Samburu. Sideways stabbing is a dangerous but only occasionally used strategy; fortunately, the skin of the oryx is unusually thick.

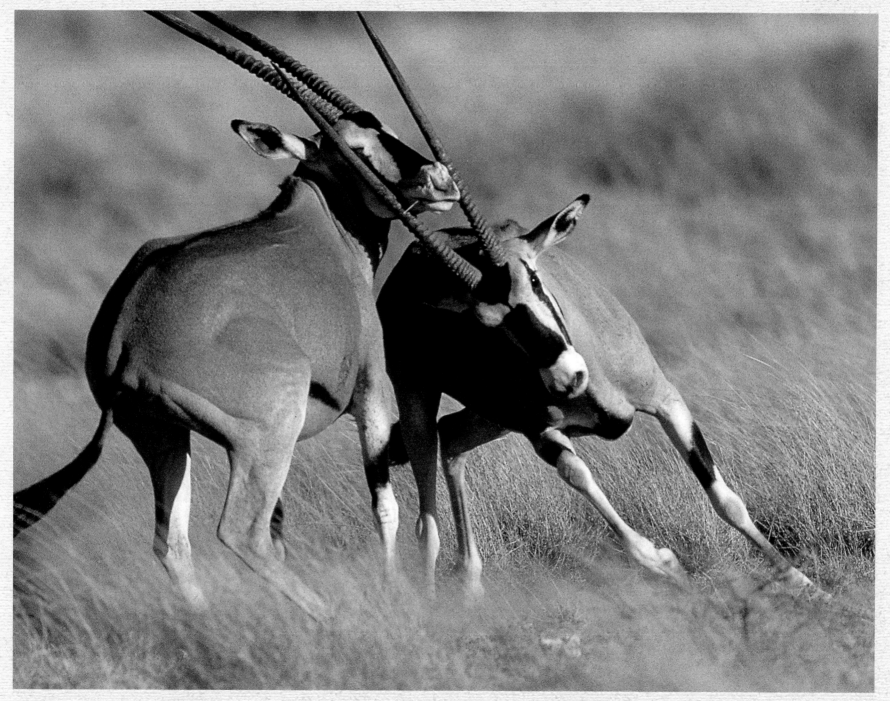

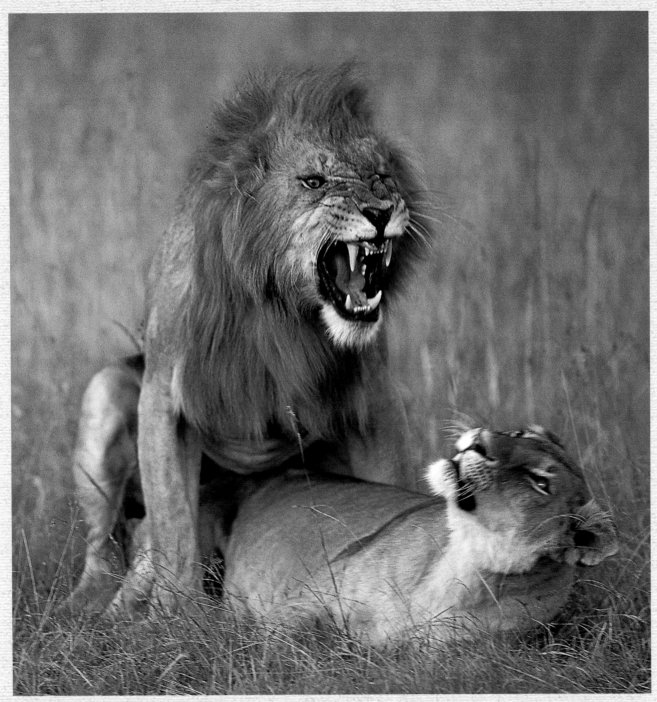

Left: The lion is renowned for its sexual prowess, but a dominant male will only reign over a pride for a few years before it is ousted by a young intruder.

Opposite: Common zebra are social creatures, congregating in small family groups made up of females, foals, and a single stallion who will defend his mating monopoly.

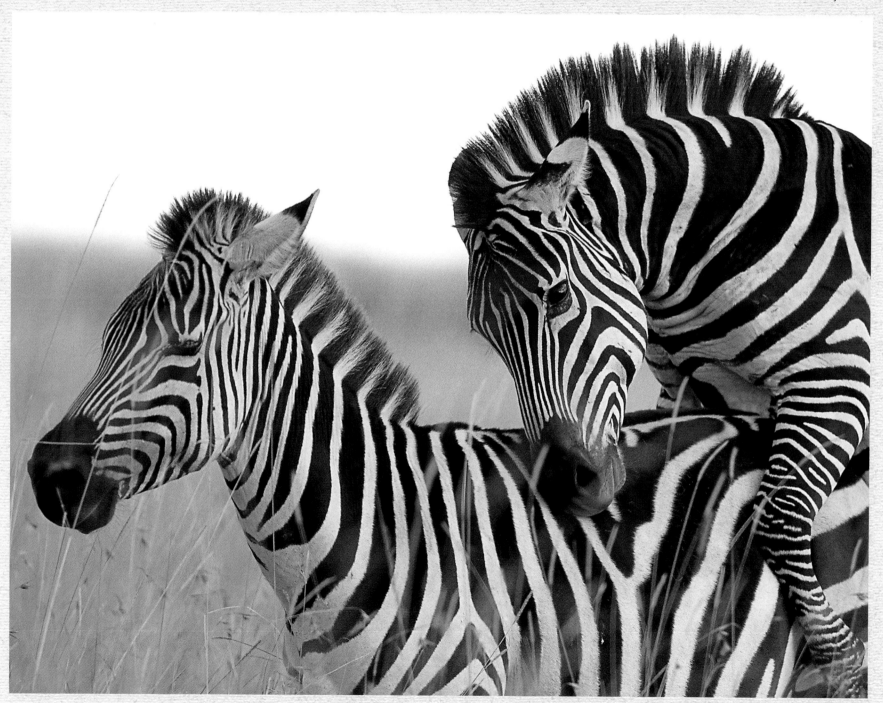

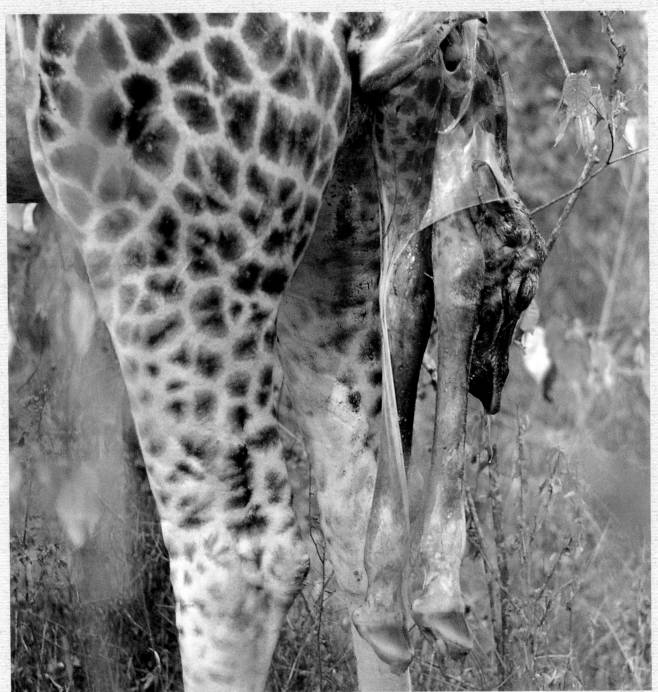

Left: The moment of birth – a familiar but still stunning miracle. A Rothschild's giraffe bears a calf, which has to survive a two-metre fall in the first seconds of its existence.

Opposite: The calf, nuzzled by its mother, will grow rapidly – the giraffe's best defence against predation is its sheer size.

Overleaf: Ostrich young are cared for by both parents. The grey legs and neck identify this as the Somali ostrich, typical of northern Kenya.

A greater flamingo checks on the progress of its downy chick.

Flamingo occasionally build nesting mounds at Lake Bogoria in the Kenyan Rift Valley, though breeding here generally remains uncompleted. The main nesting site is far to the south at Lake Natron, in Tanzania.

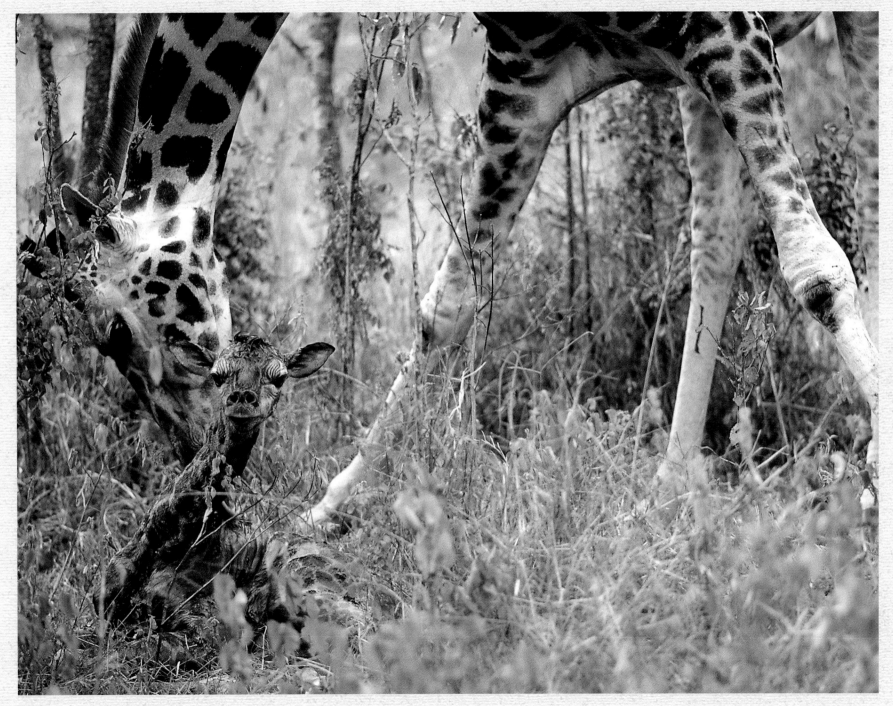

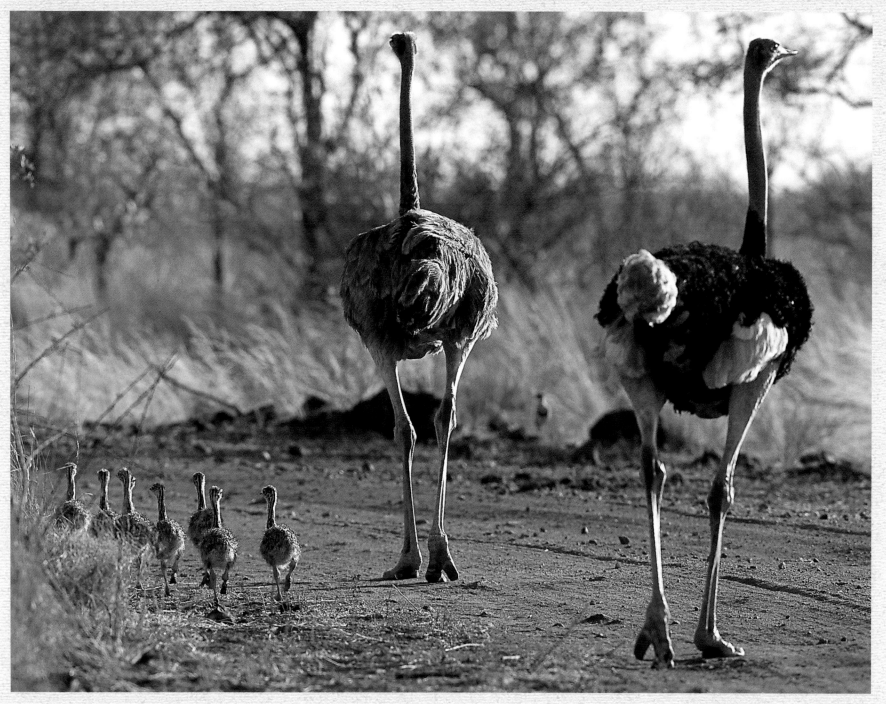

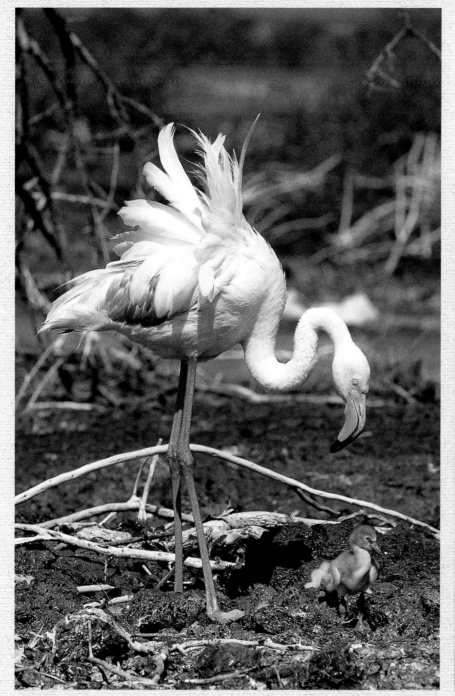

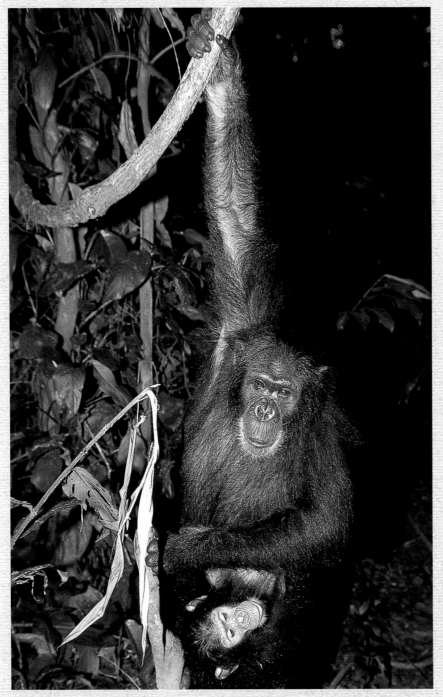

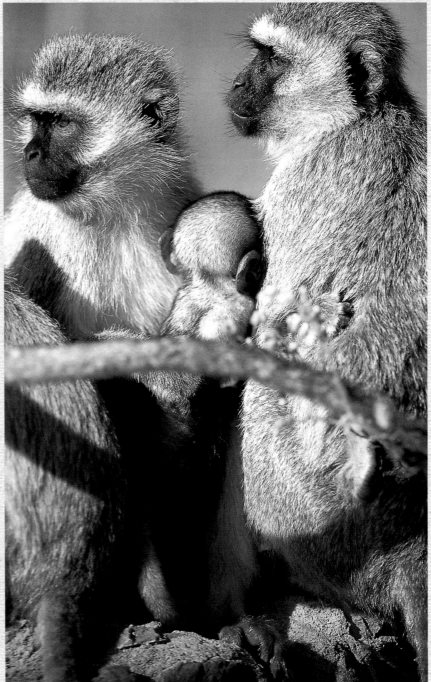

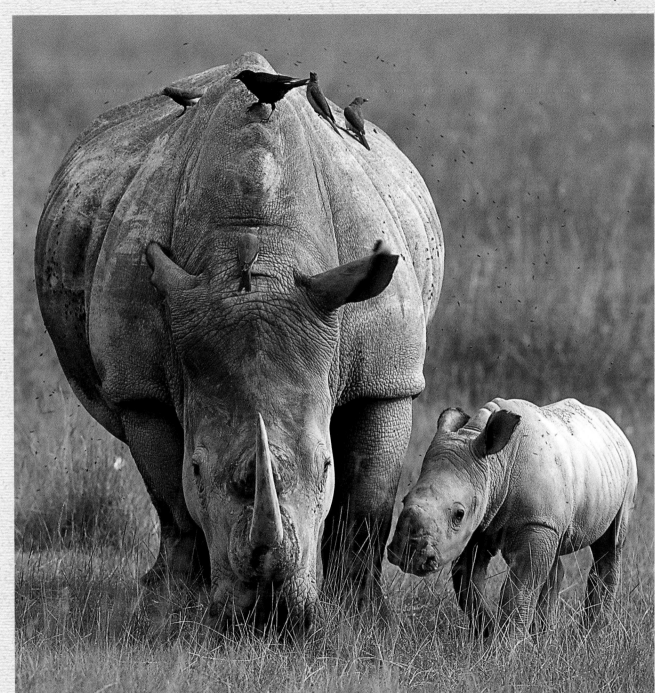

Opposite, left: Chimp and baby at Ngamba Island sanctuary, Uganda. As with humans, the weaning of young chimps from parental dependency takes place gradually over a number of years.

Opposite, right: The vervet is remarkable for the affection and fondness shown to infants. Babies are freely passed among the females of a troop, and much time is spent grooming, touching, and cuddling.

Right: White rhino and calf, with avian company. The calf will start to graze after a few months, but it will be up to a year before it is fully weaned.

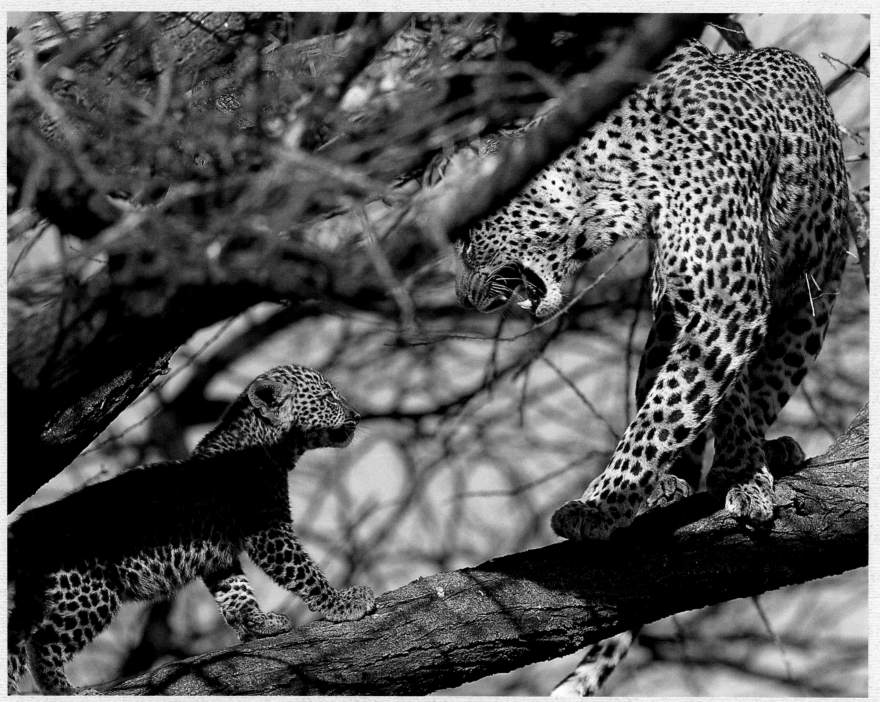

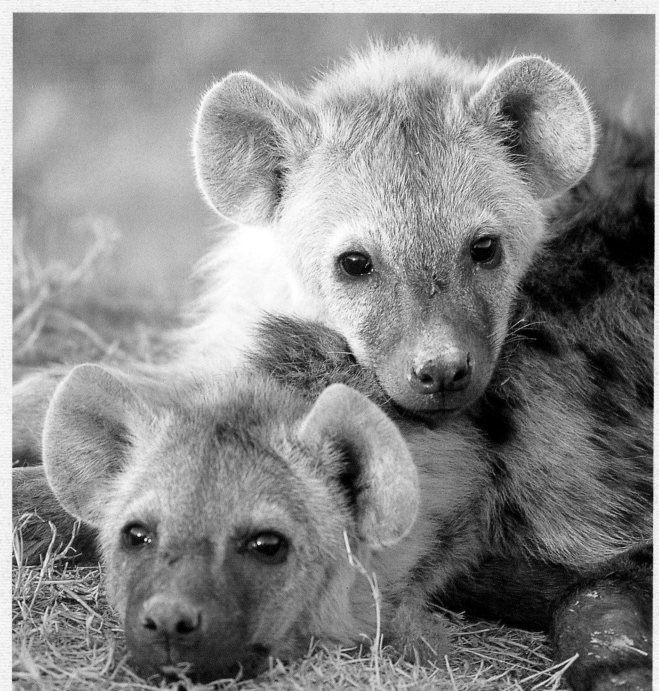

Opposite: Leopard and cub, Samburu. For the first few months of the cub's life the mother is absent hunting for long periods, leaving her offspring in a frequently changed hiding place.

Right: Hyena cubs, usually two in number, will live on their mother's milk until they are old enough to join the hunt and start consuming meat.

Overleaf: Hippo calves are vulnerable to attack by adult males as well as by predators, and are closely guarded by their mothers.

The latticed tiles of the reticulated giraffe make it a most handsome animal. Though giraffe social groupings are very fluid, mother and calf will not stray far from one another.

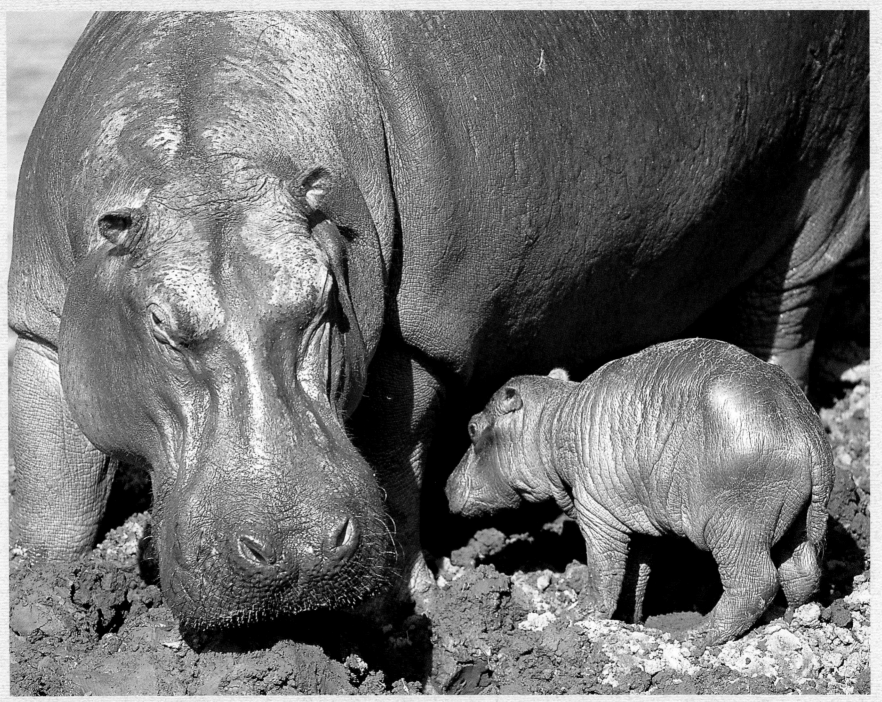

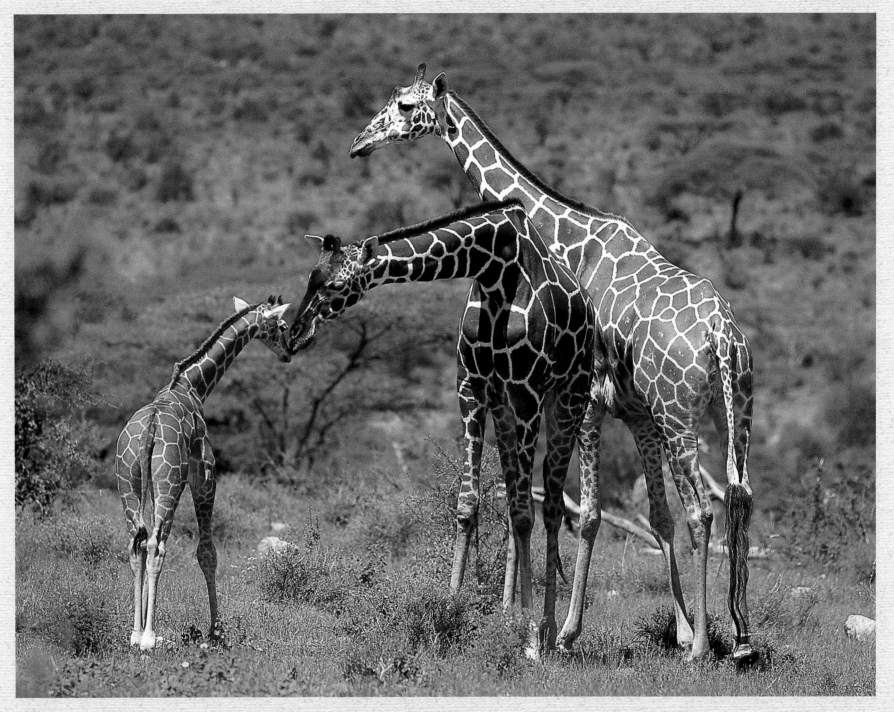

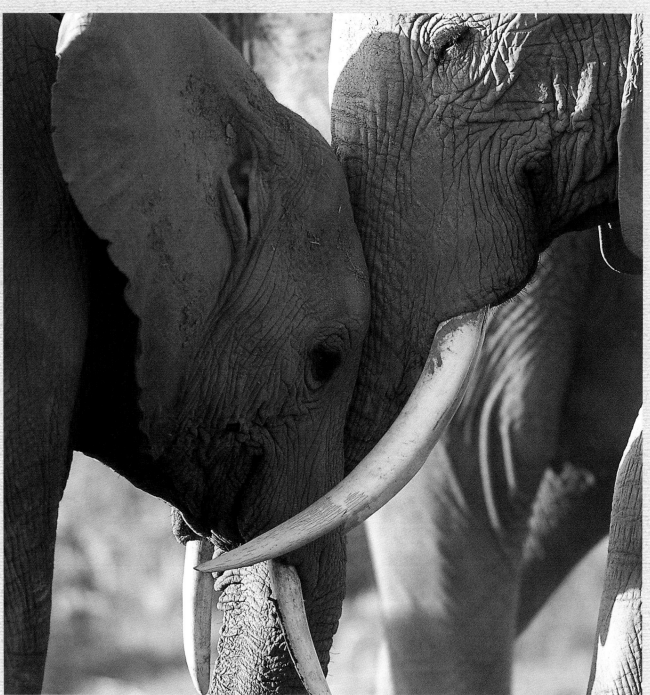

Left: The touching bond between mother and young elephant.

Opposite: Elephant are extremely protective of their young, and the calf will remain close to its mother for many years.

Opposite, right: Wisdom and gentleness seem captured in the wizened features of this Samburu elephant.

Overleaf: The battle of the giants: elephant and white rhino fall out over possession of a muddy waterhole.

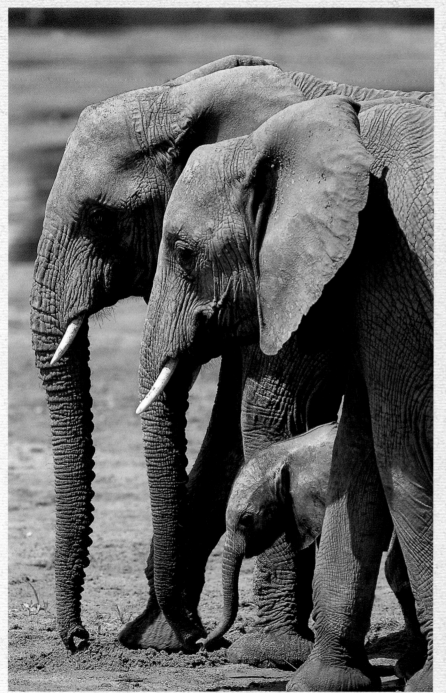

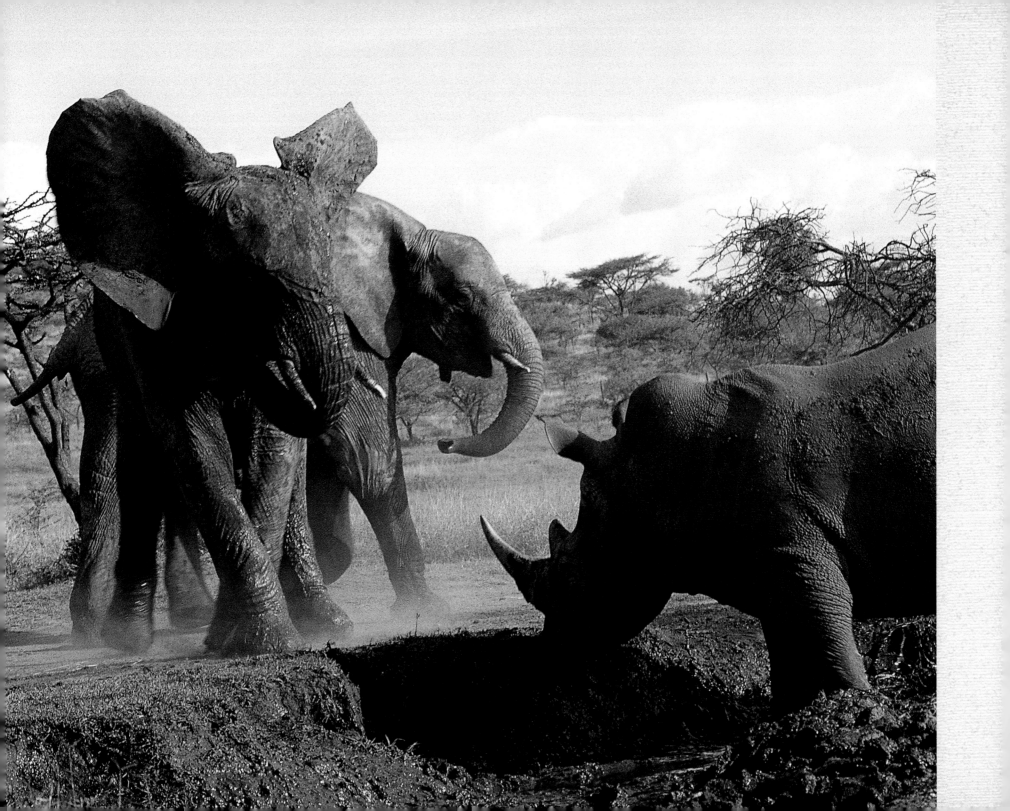

• Staying Alive •

Attack is the best form of defence, they say. Not so in the African bush, where even the slightest injury can render an animal fatally vulnerable, and each species has a wide array of techniques available for avoiding conflict and escaping potentially dangerous situations.

Danger can come from many directions. The classic duel is between hunter and hunted, and the prey has a number of tricks up its sleeve to avoid becoming a big cat's meal. If the intended victim can succeed in remaining undetected through some form of camouflage or concealment, then it can save a great deal of energy (and perhaps its life). The brown coloration typical of antelope blends with the dusty background of the bush, but who knows what the zebra, that most visible of animals, was thinking! Though it has been theorized that the stripes of a milling herd may confuse a predator.

Should that fail, it is handy to be equipped with some means of staving off the attacker. The shell of the tortoise, the spines of the porcupine, the thick hide of the rhino are effective defence shields for animals that would otherwise be extremely vulnerable.

More aggressive tools are available to some. The tusks of the warthog can inflict awesome damage, as can the horns of the buffalo and rhino. And many a lion has regretted being in range of the flailing hooves of a giraffe.

If all else fails there is always flight. For the birds this is a literal option (though less effective if your pursuer happens to be an aerially adept raptor, such as a falcon). But many animals, too, have a very handy turn of speed when it comes down to it – even a buffalo can outrun a lion once it gets up to full pace. The most impressive retreat belongs to the impala, whose graceful leaps and bounds almost turn the process of fleeing into an art form.

Predators, too, eager to maintain a clean bill of health, are often of the opinion that discretion is the better part of valour. And so the leopard, which will happily dine on domestic dogs if it can catch them off guard, has been known to flee up a tree from a single barking dog, fully aware that, while the adversary is hardly formidable, an infected bite on its paw could signal its own death warrant.

Frequently, though, the threat will come from another animal of the same species. A disagreement over territorial boundaries, a hierarchical challenge, mating rivalry – all can trigger a potentially injurious conflict. In such instances it is essential to read, and react to, the body language of the opponent. An understanding of posture and expression, and an ability to recognize hostile and conciliatory gestures, are indispensable components of family life. In fact, it is most unusual for members of the same species to fight to the death.

If you're a baboon, for example, you learn that flashing eyelids are mildly threatening, but watch out if you're being yawned at. A vervet monkey signals its confidence by the angle at which it holds its tail. In both species, a willingness to groom signals submissiveness.

Elephants confirm their position in the hierarchy by stretching up to their full height – the smaller, younger adversary will usually back down. As might be expected from such an intelligent animal, the elephant has a very wide range of signalling mechanisms, including ear slapping, trunk swishing, tusk raising, and an intimidating demonstration charge. A submissive elephant will flatten its ears against its head and arch its back.

The denizens of the coral reefs off the East African coast have developed their own set of defence mechanisms. Again, these can be purely defensive – such as the hard shells of the crab or sea turtle – or painfully aggressive, such as the venom-tipped spines of the scorpionfish.

All in all, humans are well advised to take some simple advice from the animal world's own book of wisdom – watch out for the warning signs!

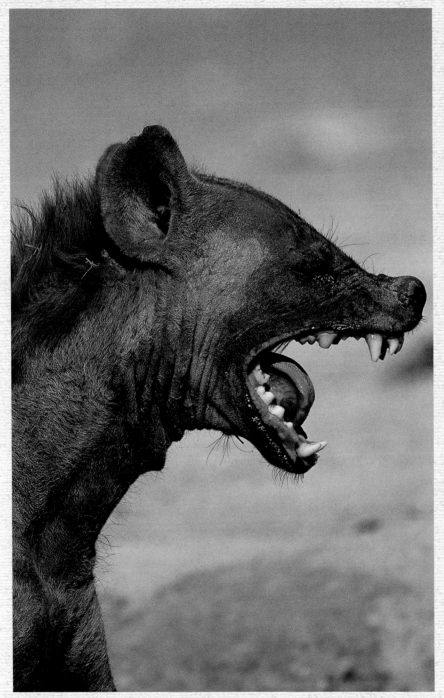

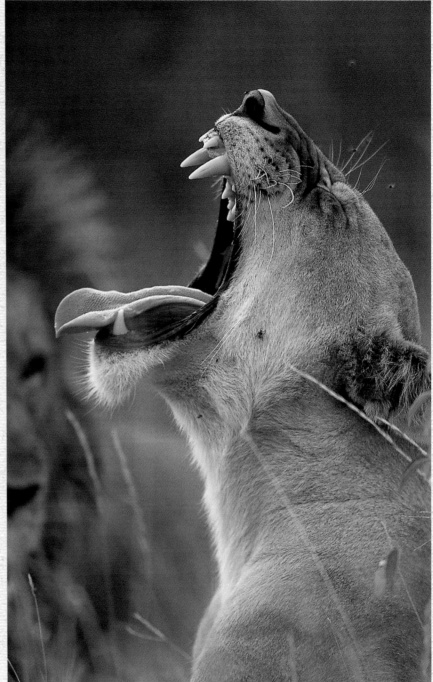

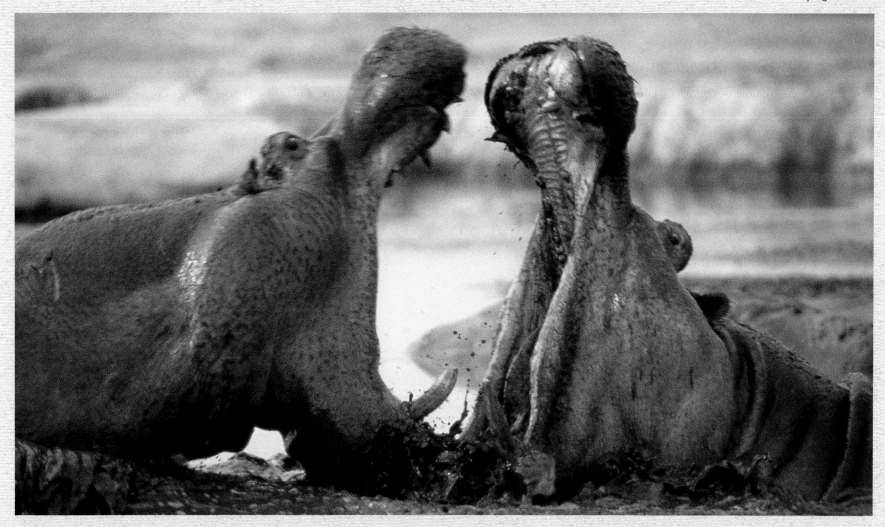

Opposite, left: The powerful jaws of the hyena easily splinter bones, and even a lion will think twice before risking confrontation.

Opposite, right: A lioness shows off her fearsome canines, Maasai Mara National Reserve.

Above: The impressive gaping yawn is one of the hippo's main threat displays, and yawning contests help establish the hierarchy within a herd.

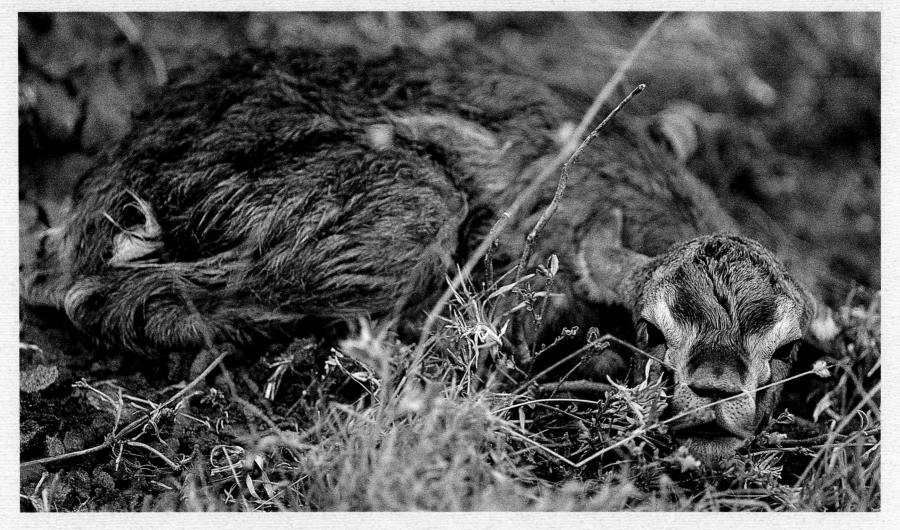

Above: During the first vulnerable weeks of its existence this newborn Thomson's gazelle will spend much of its time lying still, surprisingly difficult to spot even if there is little cover.

Opposite, above: The flap-necked chameleon, like the rest of its family, is a patient hunter, its slow pace and cryptic camouflage making it almost indiscernible amid thick foliage. It uses a quick whisk of its long sticky tongue to snatch insects that venture within striking distance.

Opposite, below: The sinister-looking crocodile fish is a feared reef predator, lying camouflaged against its background as it waits to ambush its next meal.

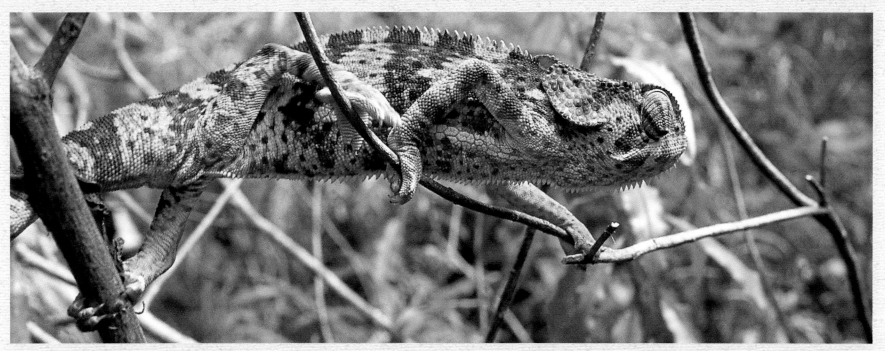

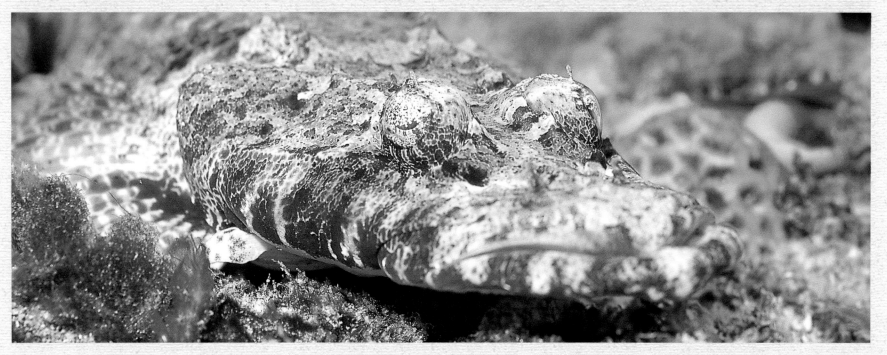

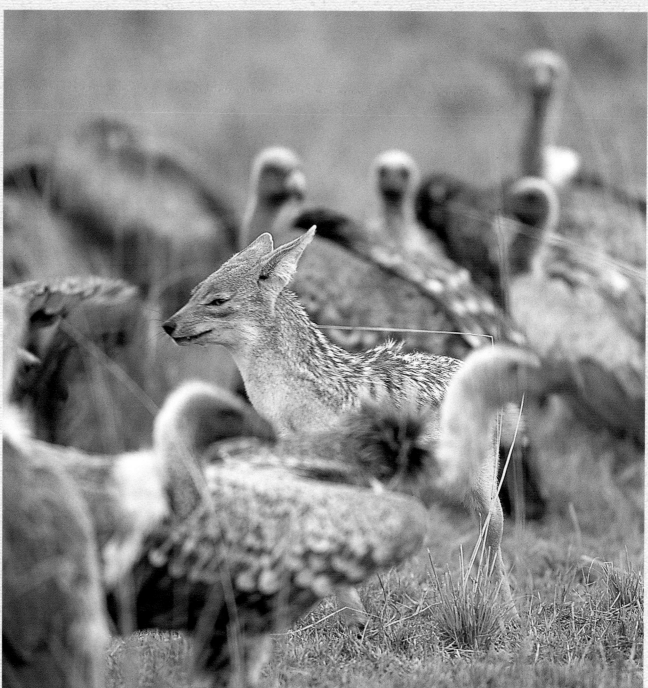

Opposite: A group of waterbuck view a crocodile with understandable trepidation. It will attack with dramatic suddenness should it decide to arouse itself from its insouciance.

Right: A scavenging silver-backed jackal warns off these pushy vultures with its 'defensive threat' posture, ears back and hair bristling. Curiously, this species is unable to raise its lips to reveal its fangs.

Following pages: The impala is perhaps the most graceful of the plains antelopes. The zigzagging leaps and bounds of its escape make it difficult for a predator to select a victim.

An elephant mother and calf at dusk, dwarfed by the massive landscape of East Africa.

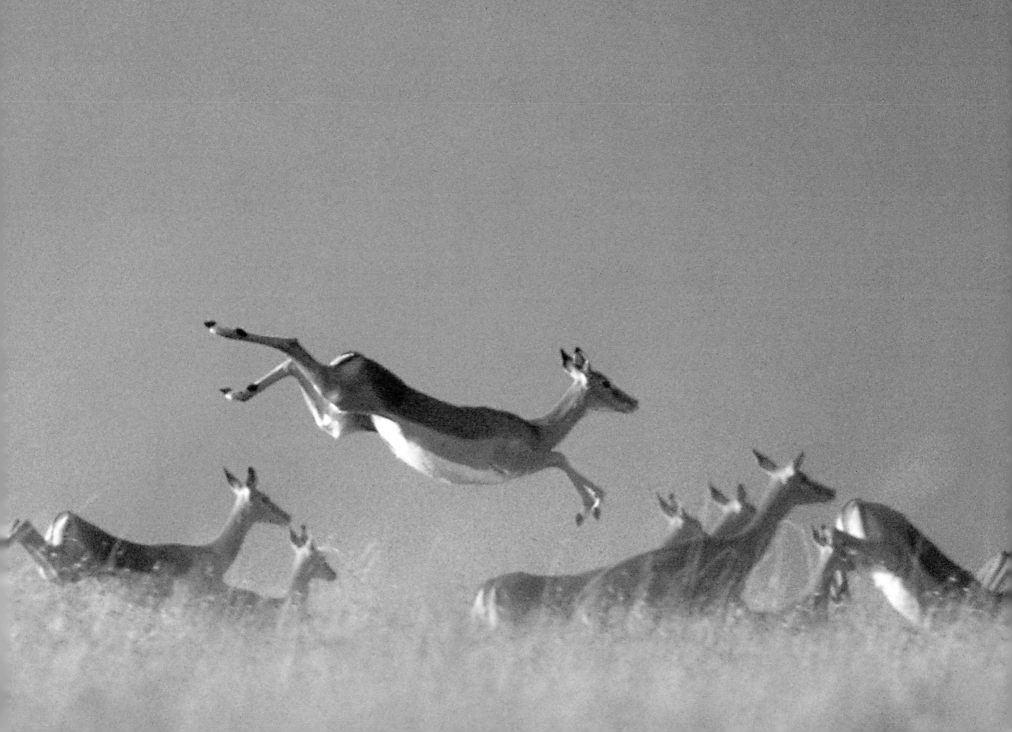

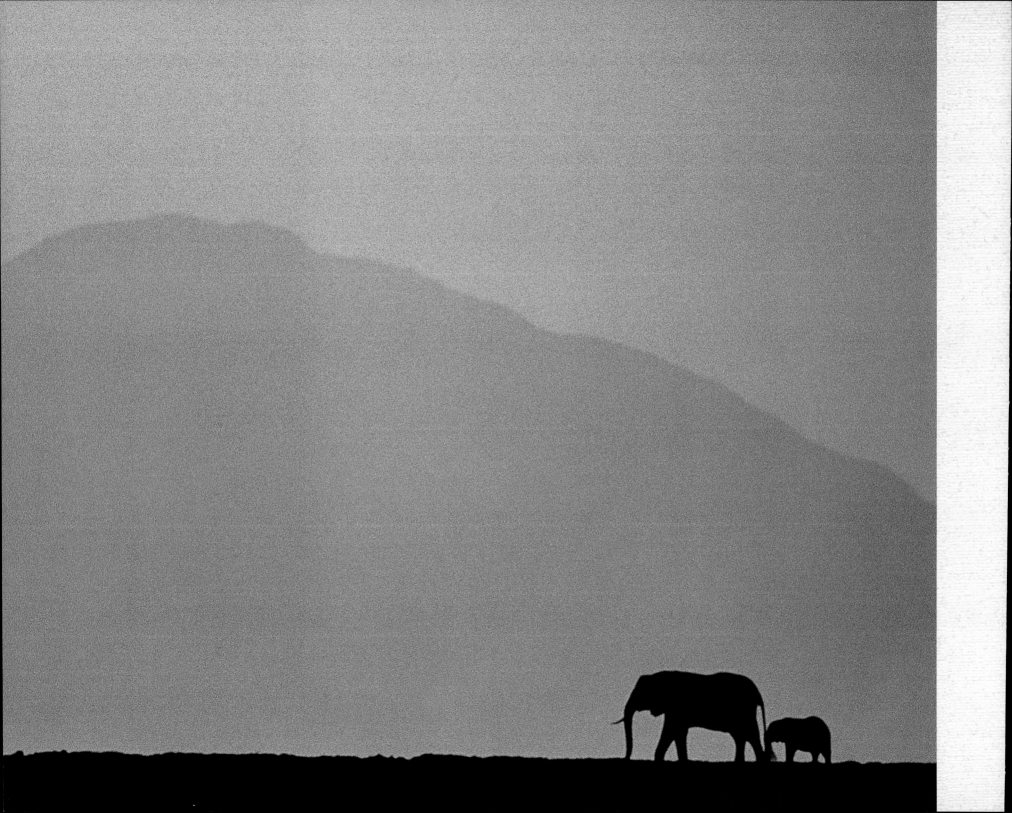

• When Night Falls •

Late afternoon, and Africa pays homage to the setting sun. Silhouetted against a fine veil of rosy cloud, a skein of cattle egrets flies back to roost with fluent purpose. From deep in the bush a robin-chat gives one last burst of its beguiling song before handing over to the sounds of the night – the churr of the cricket, the burp and plink of toad and frog, the hoot of the owl.

But even as the equatorial sun dips beneath the horizon with dramatic suddenness, a change of mood creeps over the landscape. It is signalled by the eerie yelp of the hyena and the sawing rasp of the leopard, the darkness their ally as they, and other predators, set off into the night air with deadly intent. Antelope, buffalo, zebra, and rodent are now in a state of high awareness, every sense carefully tuned to potential danger. In the bush, the night is the time of greatest peril.

The larger herbivores – elephant, rhino, and buffalo – are still active, consuming the enormous quantities of vegetation necessary to maintain their vast bulks. Their ranks are augmented by the hippo, which, before sunrise, will have ranged several kilometres from water in search of grazing.

The true creatures of the night are also abroad, nocturnal specialists, many of them with genetic adaptations to the darkness that governs their lives. The disproportionately large ears of the bat-eared fox, as well as picking up the slightest noise that might indicate a threat, are sensitive enough to detect the sound of its favourite delicacy – a dung beetle larva gnawing its way out the dung ball in which it was laid. This small fox is not particularly fast but its evasive zigzag escape from danger, with bewildering changes of direction, is enough to outfox most pursuers.

The plaintive cry of the bushbaby, piercing the night air, is one of the defining sounds of the African bush. Its huge eyes give it excellent vision as it leaps audaciously from branch to branch, but its nose is also an important guide – it scents its customary routeways through the trees with urine.

The spring hare is another truly nocturnal animal, and is so unusual that it has resisted most attempts to classify it. It seems to be a cross between a hare and a miniature kangaroo, with tiny front paws and muscular back legs which propel it forward in great leaps.

The big cats are now joined by their smaller relatives. The tuft-eared caracal, a medium-sized cat reminiscent of a lynx, preys mainly on birds and rodents. It is impressively lithe and agile, and can even pluck a flying bird out of the air with a prodigious leap. The smaller serval uses its acute hearing to locate its rodent prey in tall grasses, catching it unawares with an exaggerated pounce.

Also abroad in the night is the genet, spotted and catlike but actually of the mongoose family. It eats a broad variety of food items, including small rodents, reptiles, and fruit, but is particularly fond of mice.

Perhaps the most skilful of the night-time hunters is the leopard. A patient and stealthy stalker, it has a diverse diet, including hyrax and small antelopes – and keep an eye on your dog. It is terrifically strong, and can haul prey twice its weight high into trees away from the threat of hyena and lion. Its chosen habitat is rocky, riverine locations, but it is extremely adaptable and has coped better than most with the incursion of humans. You will rarely see this wise and wary cat – but it is there.

The long night finally draws to an end. Some have become victims, others have escaped; some have eaten, others have gone hungry. And as the earliest bird of the dawn chorus greets the first hint of daylight, those that have survived welcome the dawn of another day in the wilds of Africa.

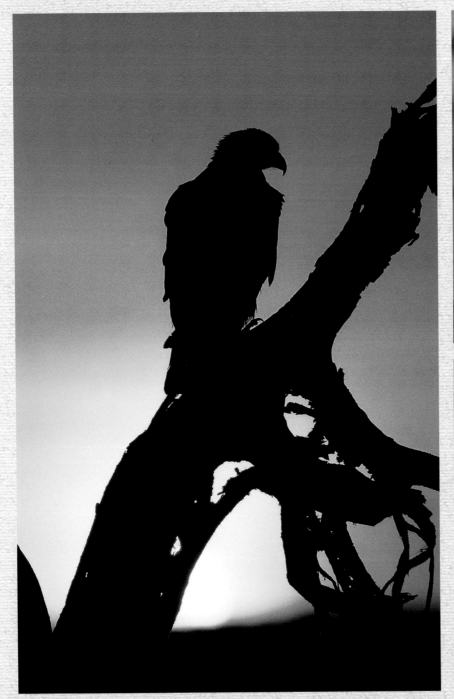

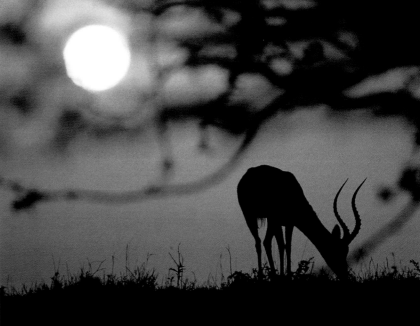

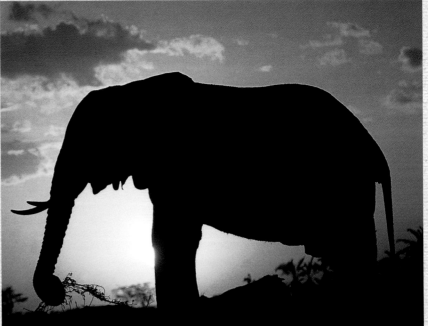

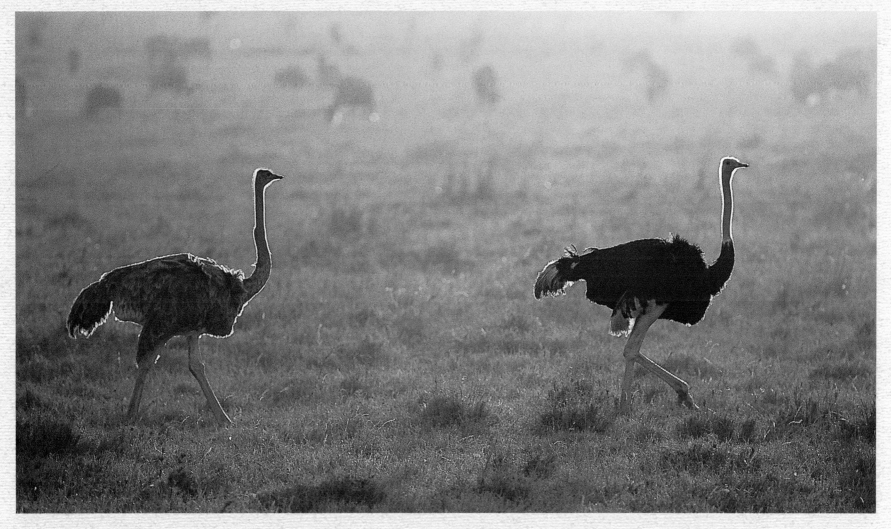

Opposite, left: A tawny eagle silhouetted against the deep hues of a Kenyan sunset.

Opposite, above right: Impala generally feed during the day, with a final feed at dusk before settling down to ruminate during the night.

Opposite, below right: To fuel its vast bulk, an elephant spends up to 16 hours a day feeding, and is often active through the night.

Above: A pair of Maasai ostrich hurry across a backlit stage.

Overleaf: The radar ears of the serval scan the Maasai Mara bush for prey, and danger, as it commences its dusk patrol.

The big cats, too, rise from their slumber as night falls; this pride has already located a wildebeest, which will engage their attention for much of the night.

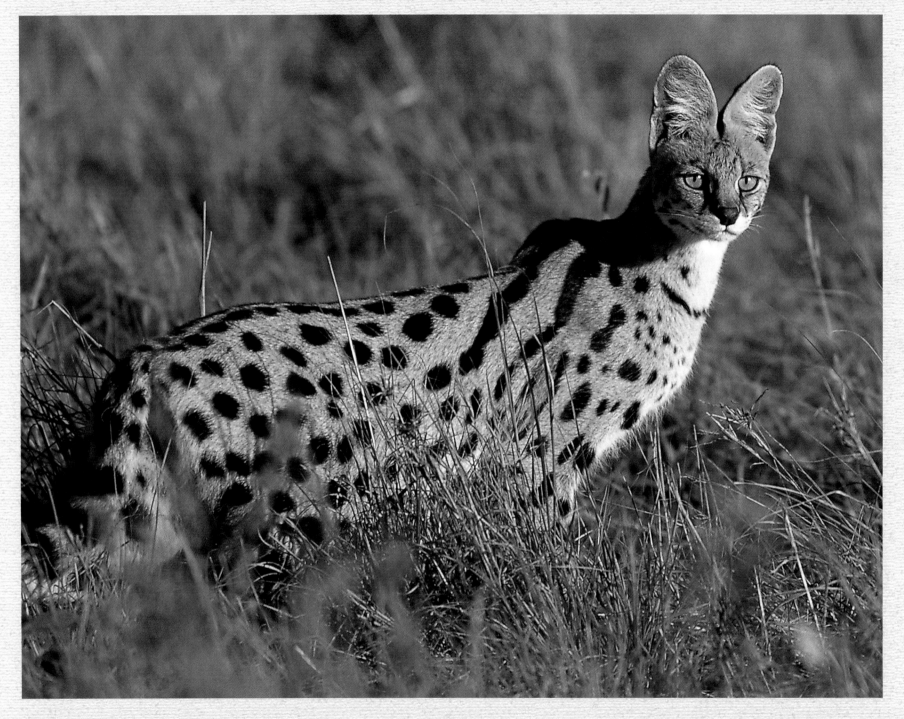

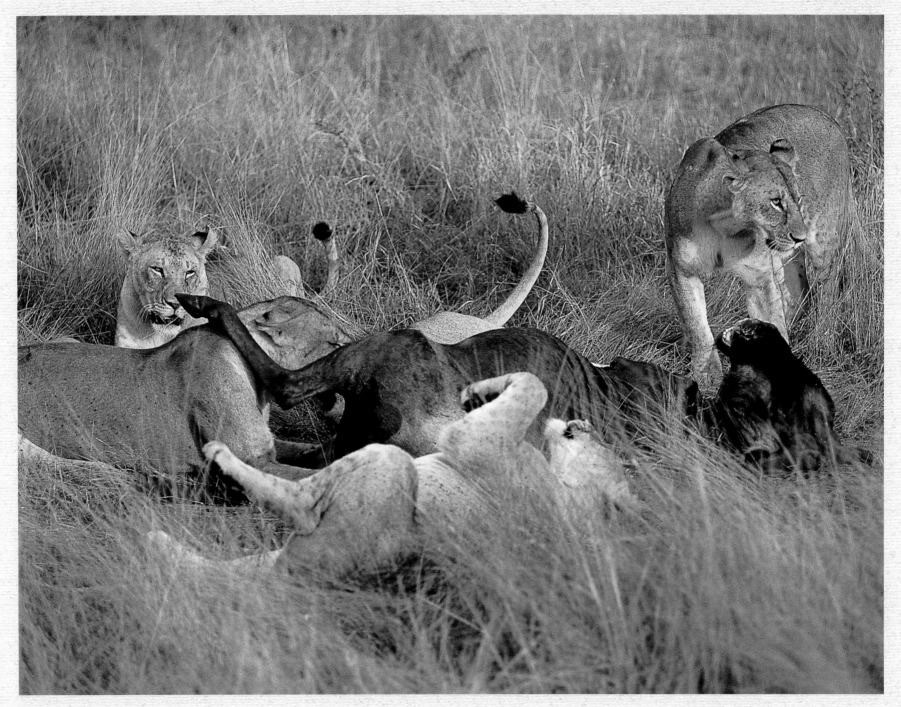

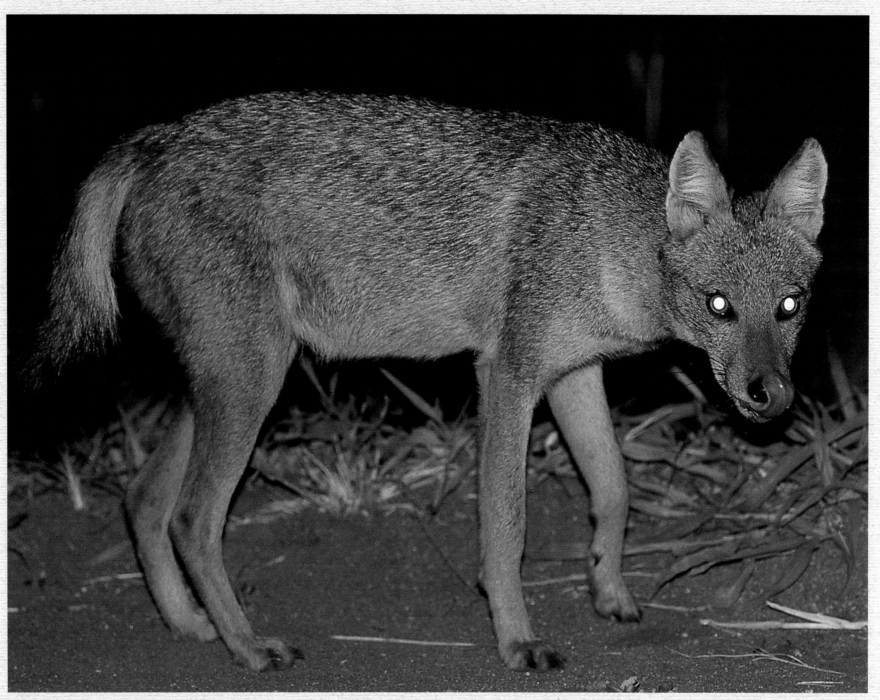

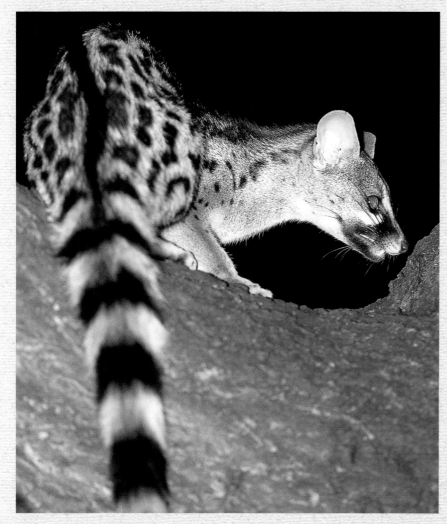

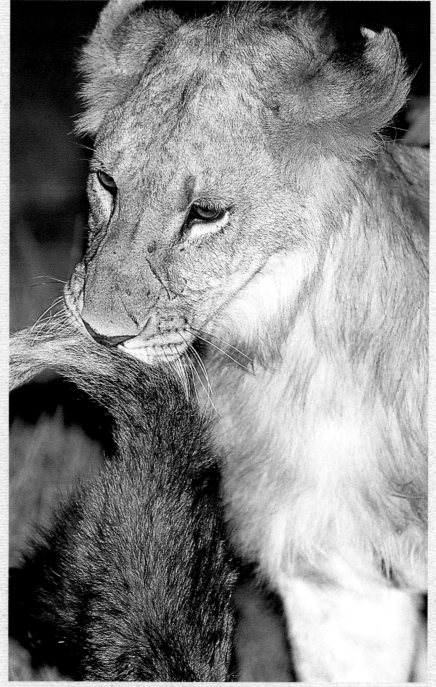

Opposite: Golden jackal, Kidepo National Park, Uganda. This jackal is resident throughout North Africa but its nocturnal habits mean it is rarely seen.

Above: A genet in Samburu, Kenya. These catlike members of the mongoose family eat rodents, birds, and insects, as well as fruit.

Right: The white-tailed mongoose is strictly nocturnal, spending much of the night foraging for insects. This one was unfortunate to encounter a lion doing much the same, though somewhat further along the food chain.

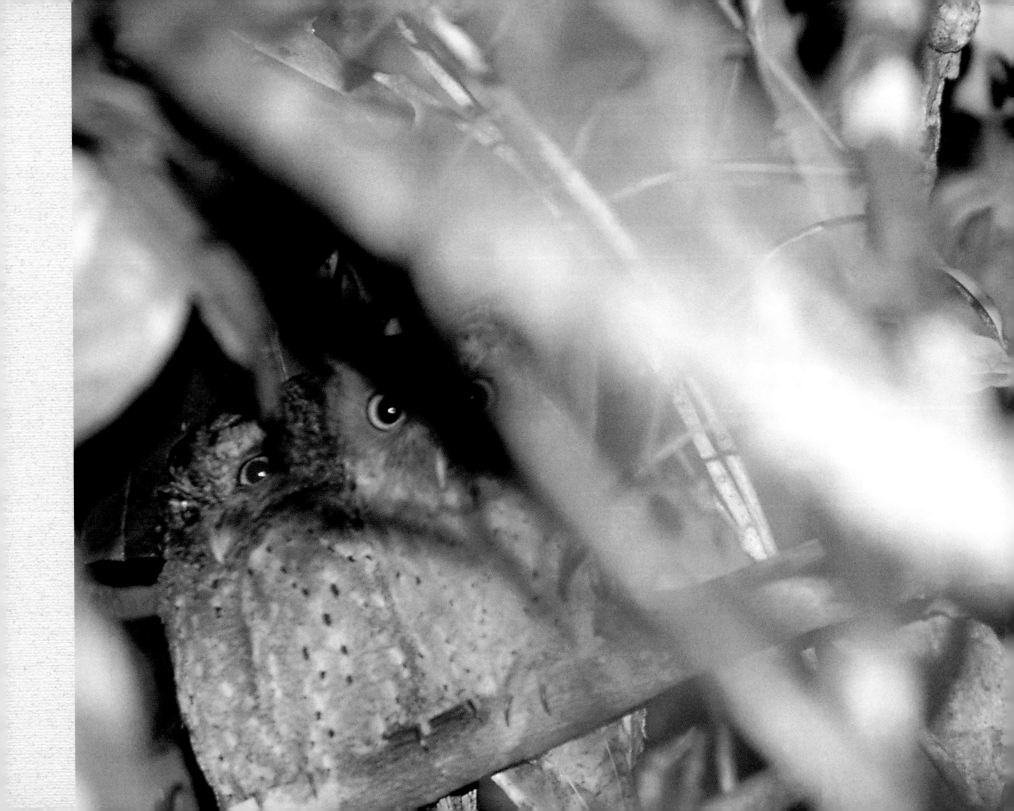

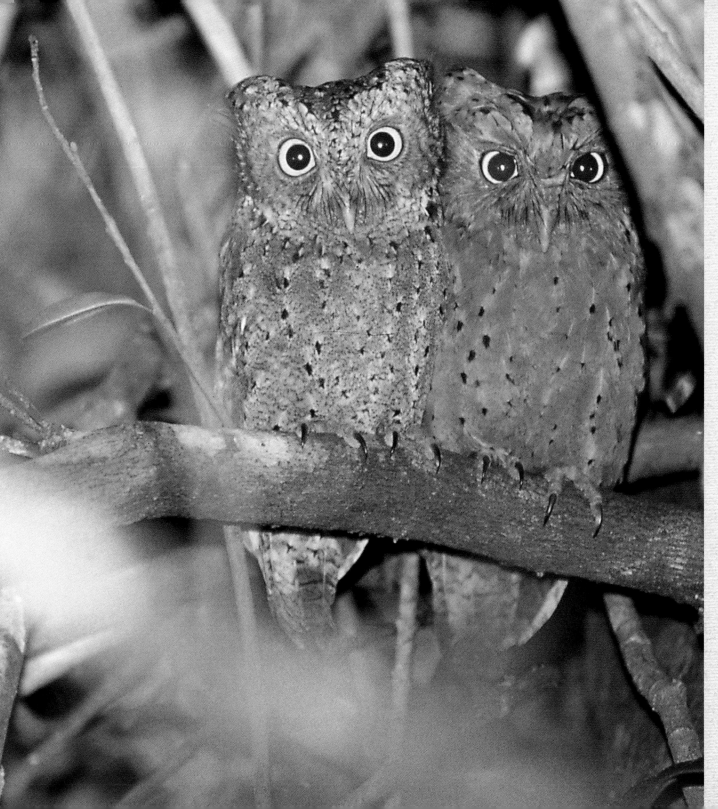

Left: The Sokoke scops owl, only discovered in 1965, is restricted to the Arabuko-Sokoke Forest of coastal Kenya and the East Usambara Mountains of Tanzania. It comes in three colour morphs: brown, rufous, and grey.

Overleaf: The lionfish is beguilingly decked with streaming ribbons, but stay clear. The fin spines are needle sharp and are connected to virulent venom glands that can administer an unpleasant sting.

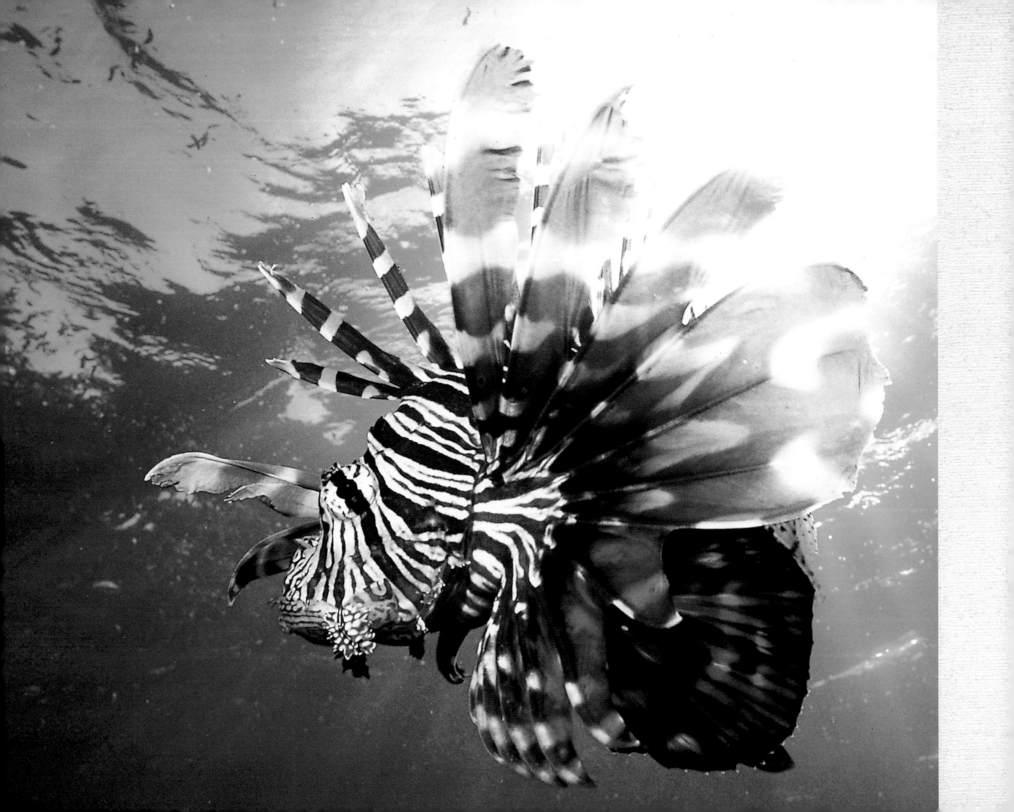

• An African Rainbow •

The iridescent metallic greens and violets of the sunbird, the gaudy patterns of the fish that inhabit the coral reef, the blue body and red head of the agama lizard – throughout East Africa, air, sea, and land are illumined by flashes of glorious colour.

How are these colours produced? They are generated mainly by pigments, chemicals that absorb certain wavelengths and reflect others, which the eyes then pick up as different colours. The main pigment is melanin, which is responsible for the shades of black, brown, and grey that are typical of the bush animals.

Birds, not surprisingly, have a second string to their bow. Their stunning blues and iridescent sheens are 'structural' shades, produced not by pigments but by the reflection of light from minute particles or filaments in the feather. Only one bird produces its own blue pigments – the turaco.

This impressive rainbow of colour that graces the animal kingdom has two primary functions, which are just about mutually exclusive. On the one hand, it is advantageous to have plain or cryptic shades that provide camouflage against potential threats. On the other hand, conspicuous bright hues can warn off predators, or help attract a mate. How a balance is achieved between these two apparently contradictory requirements is one of the most fascinating aspects of the animal world.

Birds and fish both use countershading to help conceal themselves. They are lighter below than above, cancelling out the shadow effect which gives shape and form to a body, increasing its visibility. In addition, birds that spend much time on the ground, such as the lark and the bustard, often have a busy back pattern of browns and buffs, making them hard to discern in their habitat. This is particularly important during incubation, when the bird spends long dangerous hours sitting on its eggs.

Even the more vivid colours can act as a form of camouflage. The complex patterns of many coral reef fish (and the zebra, of course) can disrupt the vision and make the shape of the creature difficult to define. It is the fish of the shallow waters that are most spectacular, and their eyes are adapted to see a wider spectrum of colours than the fish of the darker depths. Several coral reef fishes also have the ability to avoid detection by changing colour.

The classic exponent of this art is, if course, the chameleon. It achieves this, incredibly, by opening and closing cells which direct sunlight to different pigments. Recent study has shown that chameleons perform this feat not only for concealment, but to communicate a range of moods.

There are times, however, when conspicuousness is desirable. For this reason the males of many bird species are far more obviously coloured than the female (the painted snipe is a rare exception), and use their high-profile visibility to announce themselves to prospective mates, or to warn other males out of their territory.

A number of birds have found a way round the clash between the twin requirements of concealment and advertisement. Male weavers, for example, are typically bright yellow during the breeding season when they want to attract a mate, but wear much drabber plumage at other times of the year. Also, many bird species are sexually dimorphic – the male attracts mates with showy coloration, while the female is cryptically coloured for incubation. Or perhaps the striking colour mark might be hidden at rest, as is the speculum on the wing of a duck.

Whatever the reason, the onlooker can be grateful that Nature has seen fit to adorn her children with the wonderful splashes of colour that embellish the air, lands, and seas of East Africa.

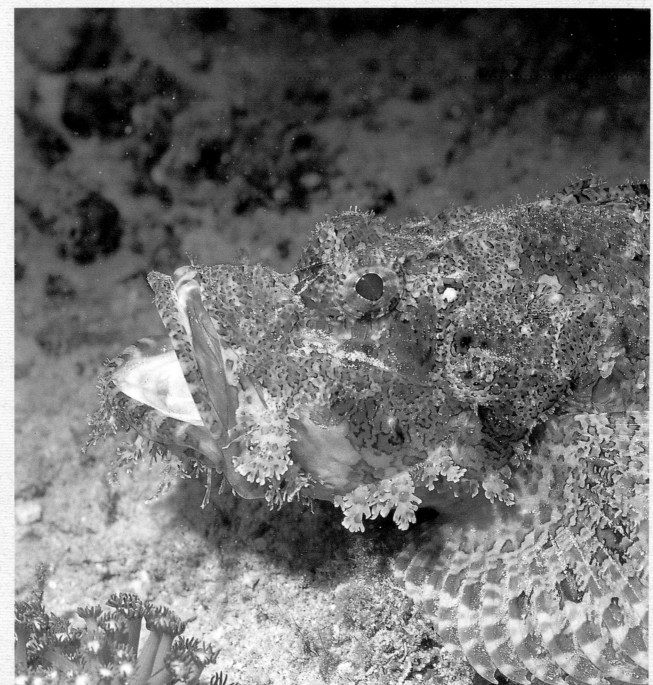

Opposite: Beware – the spines of the leaf fish can emit a toxic poison. It is predatory, eating other small fish and marine animals, and has many colour phases including yellow, green, brown, purple, and the relatively unusual red form pictured here.

Right: The raggy scorpionfish is another occupant of the reef whose fantastic appearance conceals a painful defence system.

Overleaf: A shoal of cardinal fish, common inhabitant of the Indian Ocean reefs.

The huge Napoleon wrasse has a facial pattern reminiscent of traditional New Zealand face painting, giving it its alternative name – the Maori wrasse.

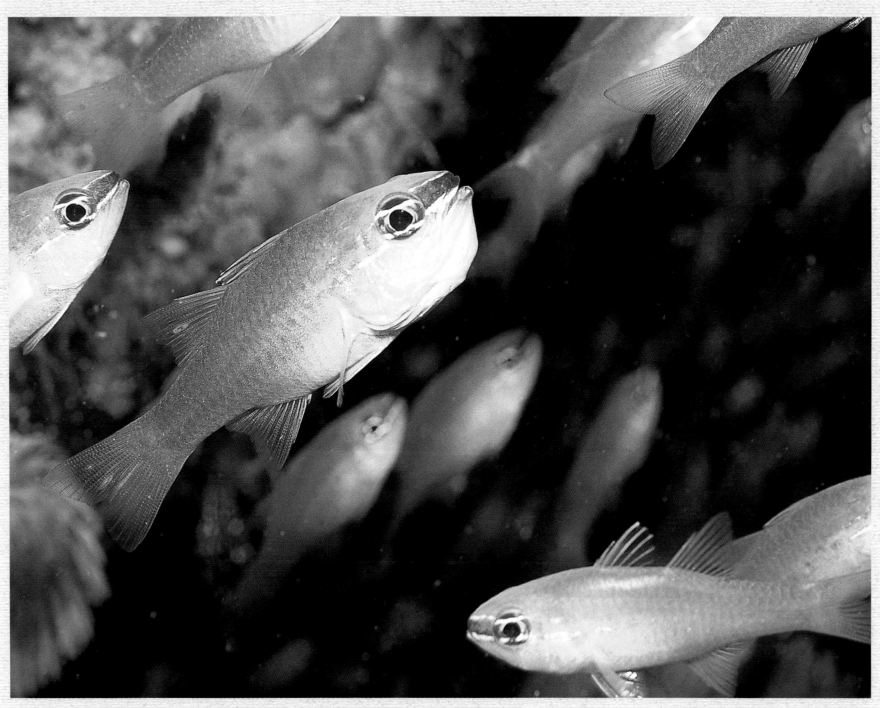

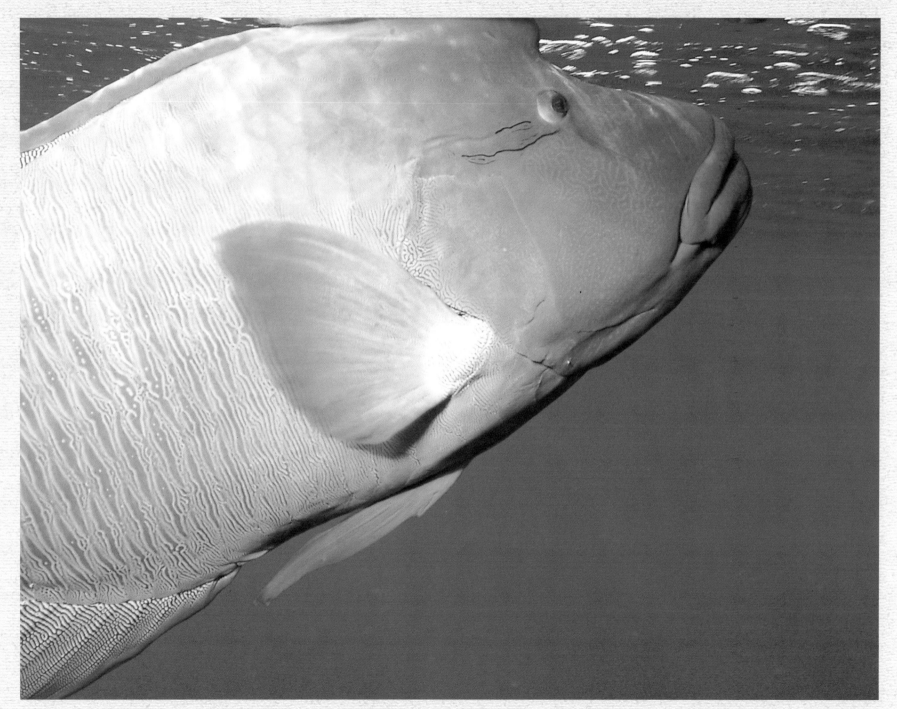

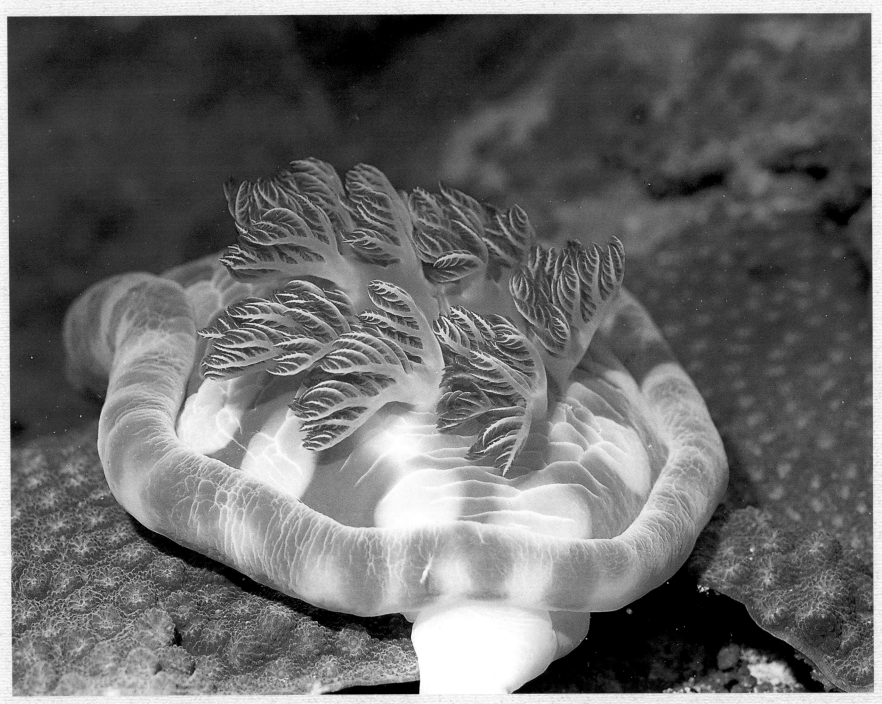

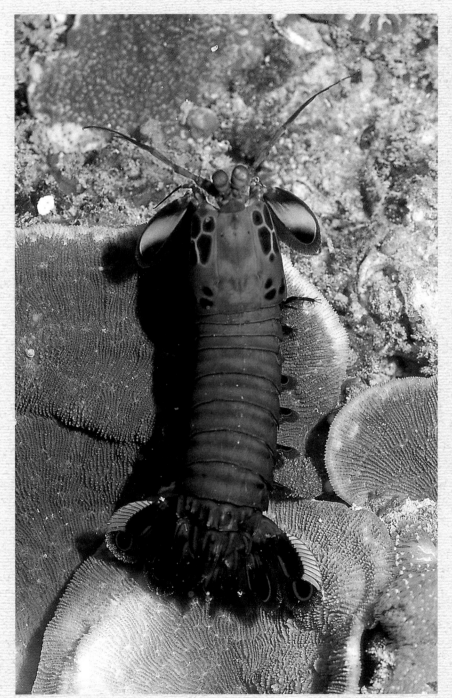

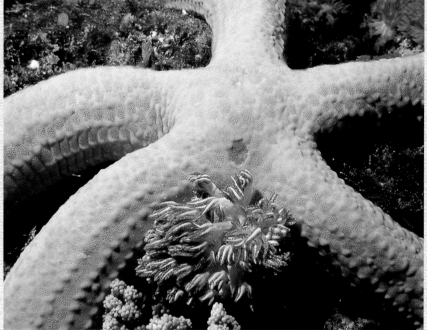

Opposite: The delightful, delicate Spanish dancer, its pink and white 'skirt' crowned with the red and yellow ribbons of its external gills.

Left: The mantis shrimp is attractively coloured, but again, don't get too close – a concealed claw unfolds with brutal force to impale prey (and the fingers of the unwittingly curious).

Above: The five-fold symmetry of the starfish is only disturbed by the off-centre madreporite, the intake valve for its internal hydraulic system.

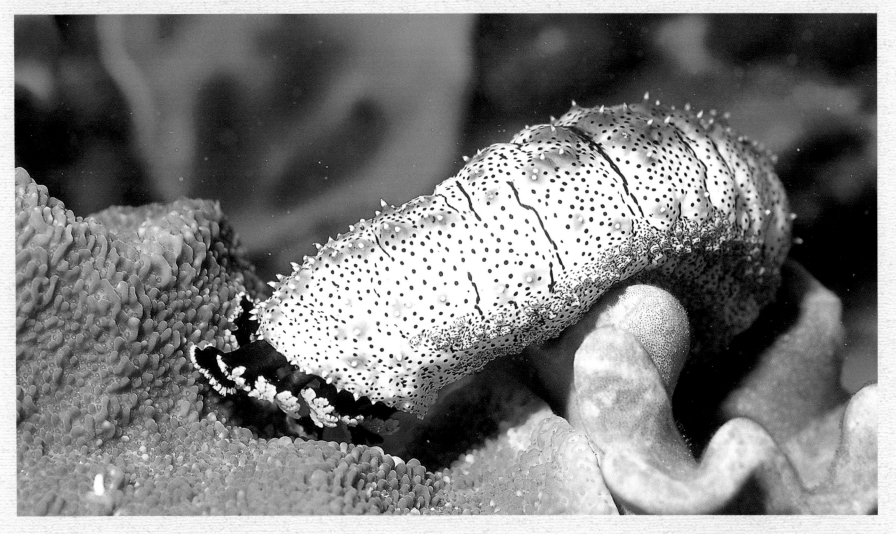

Above: Graeffe's sea cucumber uses the 'paws' emerging from its mouth to pick up the small organisms that constitute its diet.

Opposite: The sea apple is a brightly coloured species of sea cucumber.

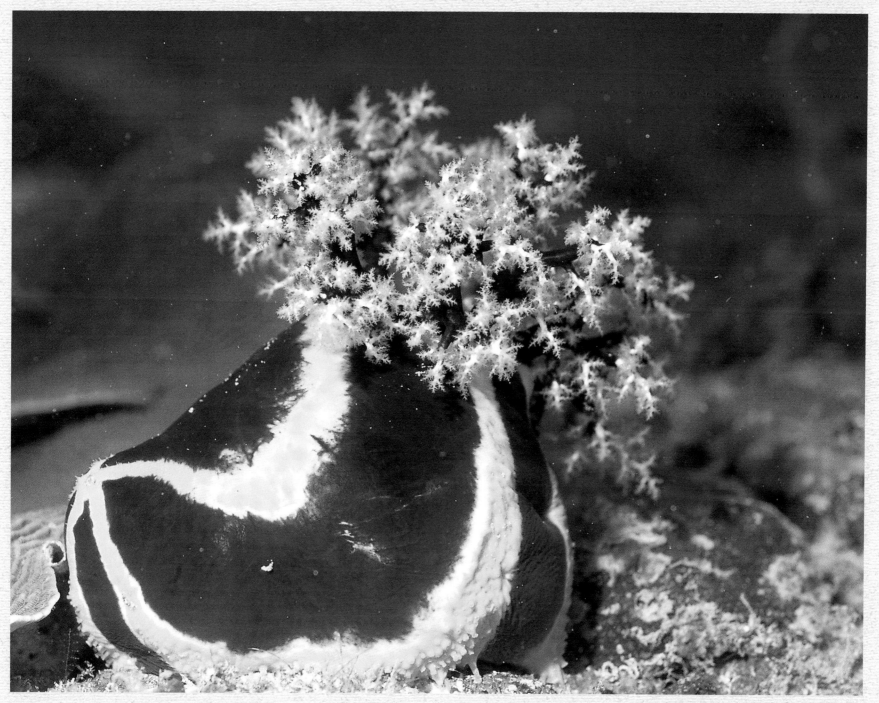

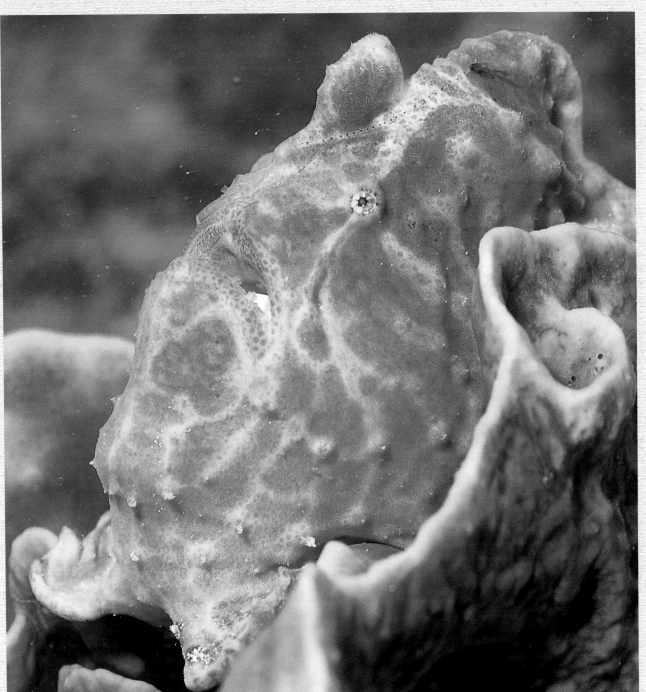

Left. The frogfish is surprisingly inconspicuous as it drifts around the reef, but lunges with startling speed to engulf a passing fish in its cavernous mouth.

Opposite, left: The beautiful ribbon eel is a carnivore, and can grow to over a metre in length.

Opposite, above right: The giant clam is a bivalve mollusc which can weight over 200 kilograms.

Opposite, below right: The octopus is a carnivorous mollusc with a well-developed brain and eight suckered arms, amongst which is hidden a beak that is capable of piercing the shell of a crab and injecting a fatal poison.

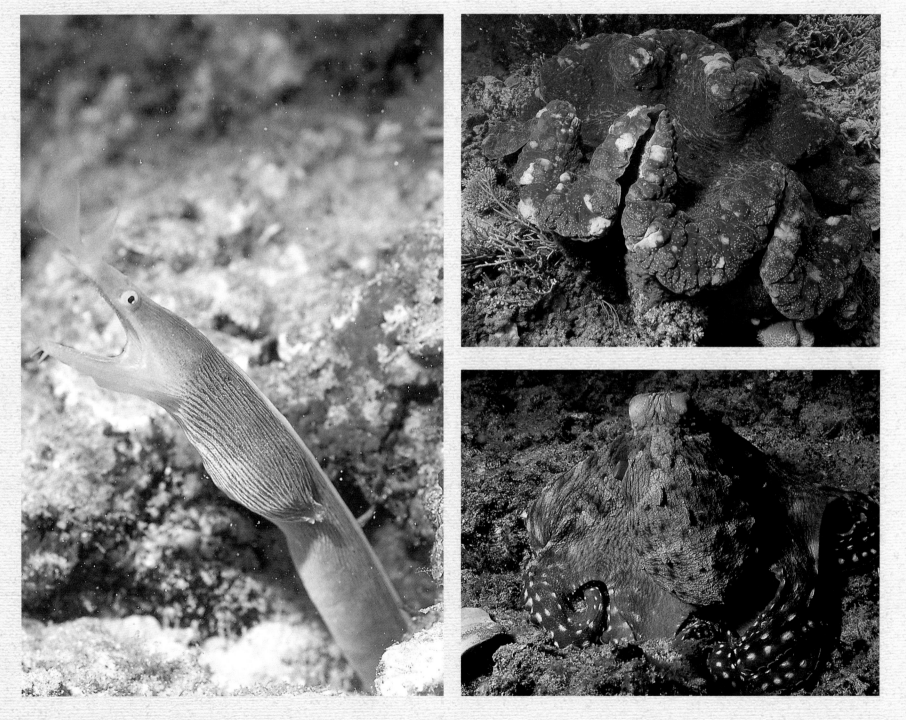

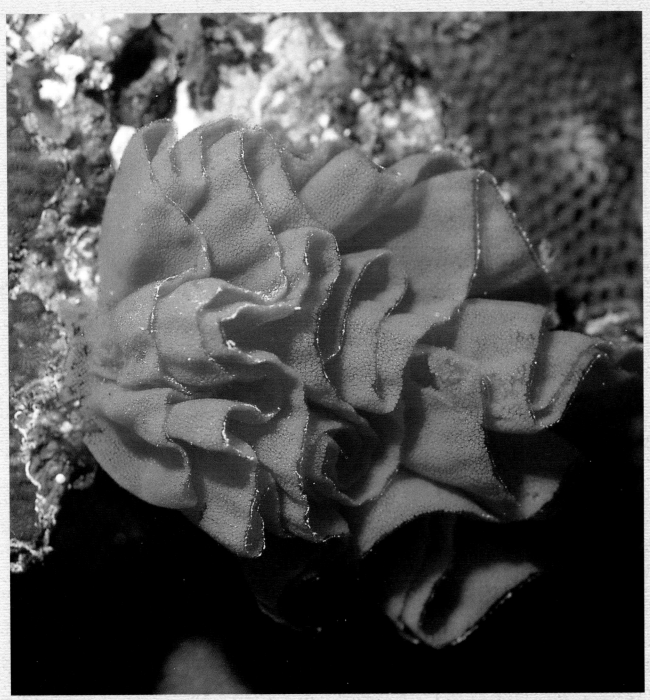

Left: The bouquet-like mermaid's purse is in fact the egg cluster of a nudibranch or sea slug.

Opposite: The fan worm filters the water for food with its waving fan, which it immediately withdraws into its tube if threatened.

Overleaf: Nudibranchs are shell-less marine molluscs. They derive their name from their exposed gills, which add a decorative plume to their boldly patterned bodies.

The hermit crab squeezes its soft abdomen into a shell which will be its armour-plated home until the crab outgrows it and 'upgrades' to a larger shell.

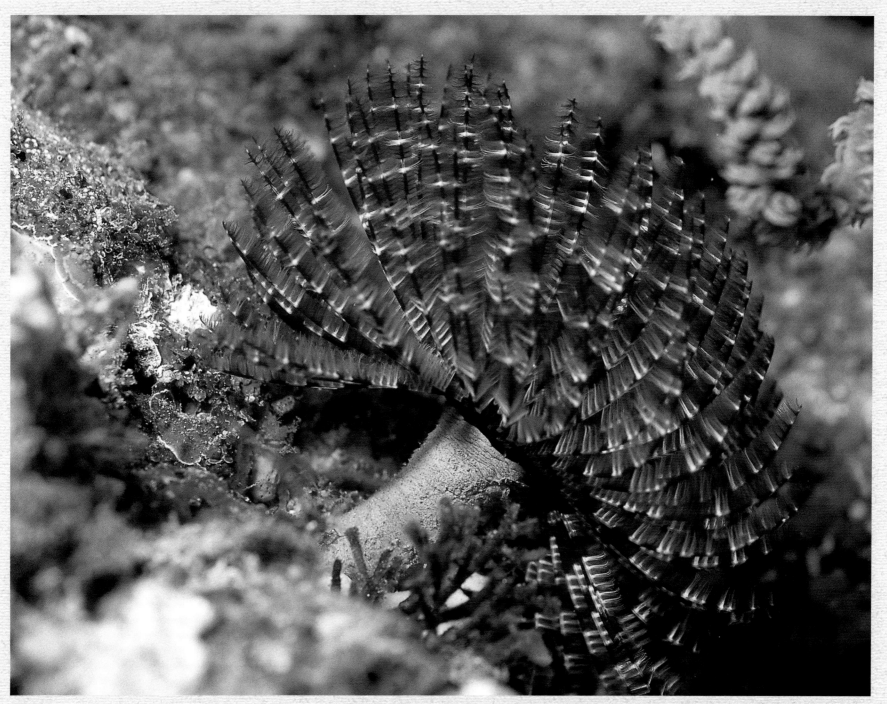

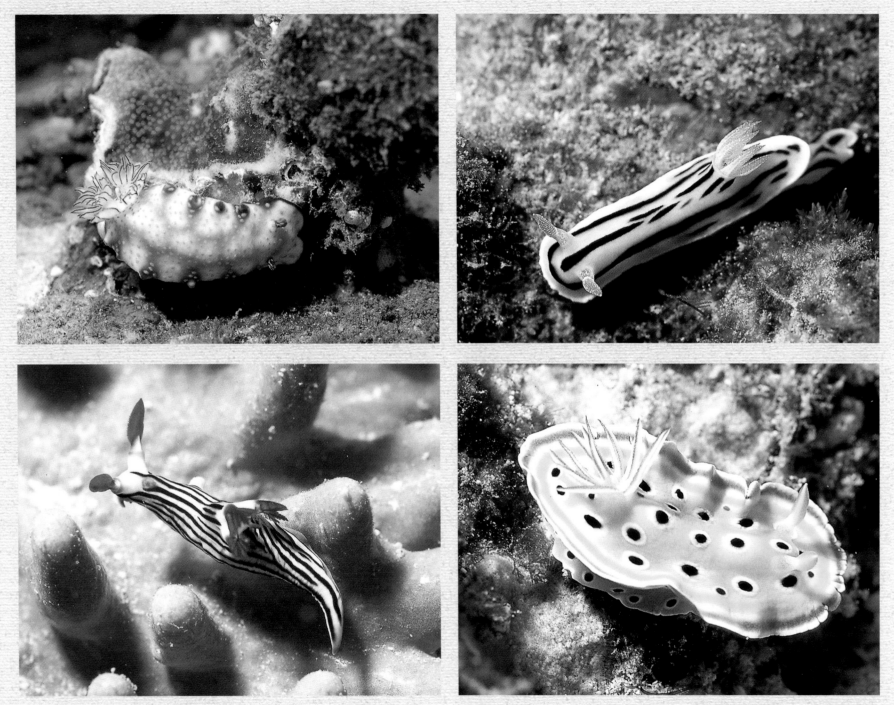

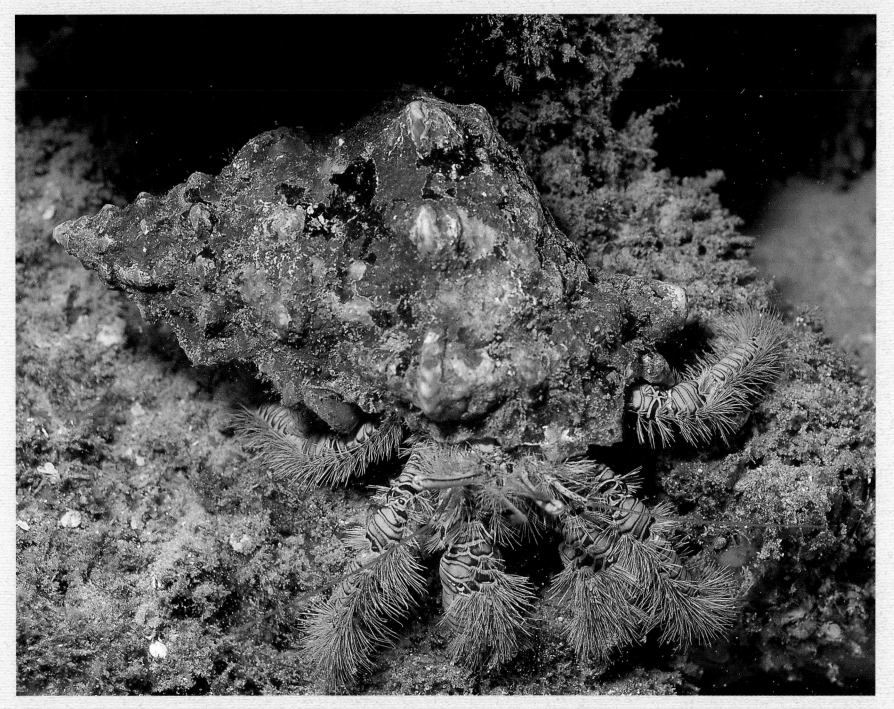

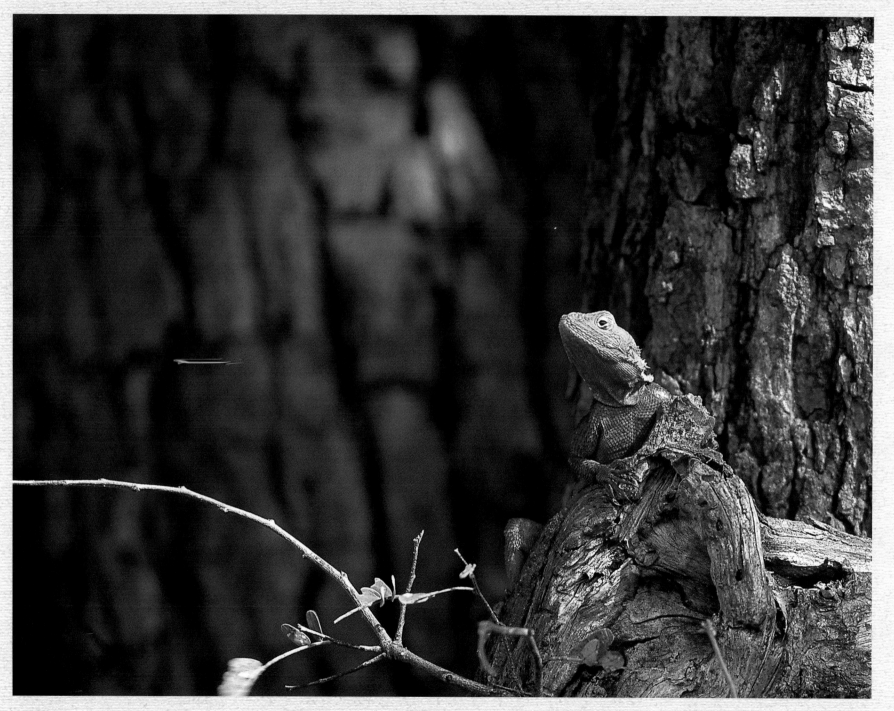

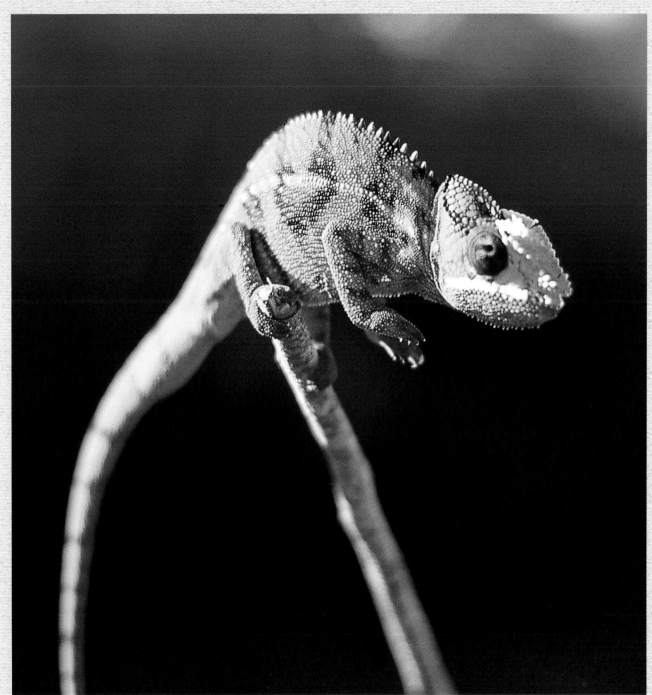

Opposite: The red head and blue body of the male agama make it one of the most striking of the African lizards.

Right: The panther chameleon is indigenous to Madagascar and comes in a wide range of colour morphs.

Left: The red-billed firefinch is one of the most confiding East African species – I've even had one nest in my bedroom.

Opposite, above left: The white-throated bee-eater is just one of a dazzling family. The bee-eater is adept at removing the sting from a captured bee before consuming it.

Opposite, below left: The brilliant colours of the lilac-breasted roller are seen best during its acrobatic 'rolling' display flight.

Opposite, right: The wattled plover prefers the moister habitats of the Mara-Serengeti plains.

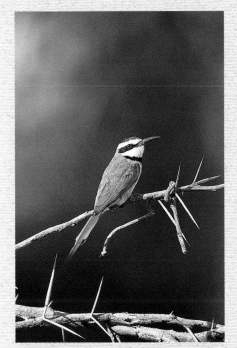

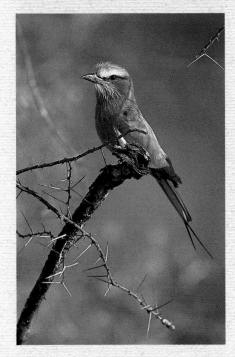

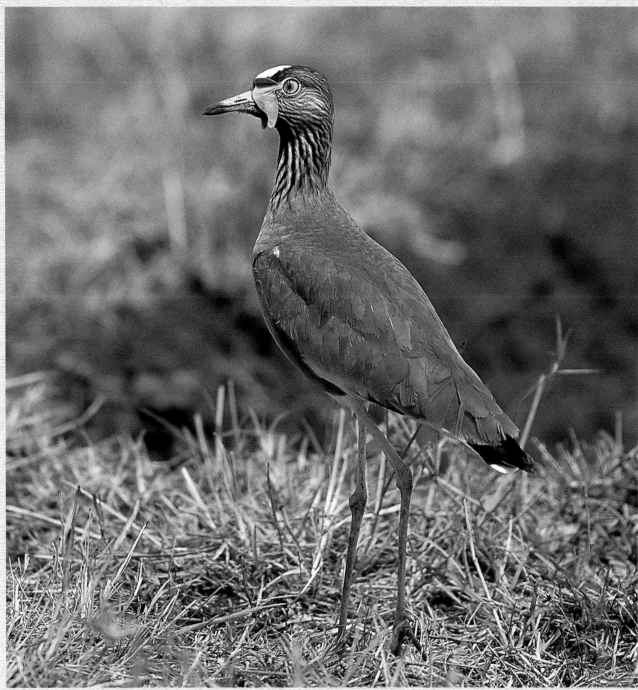

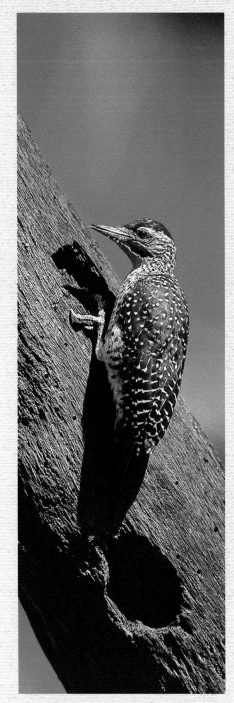

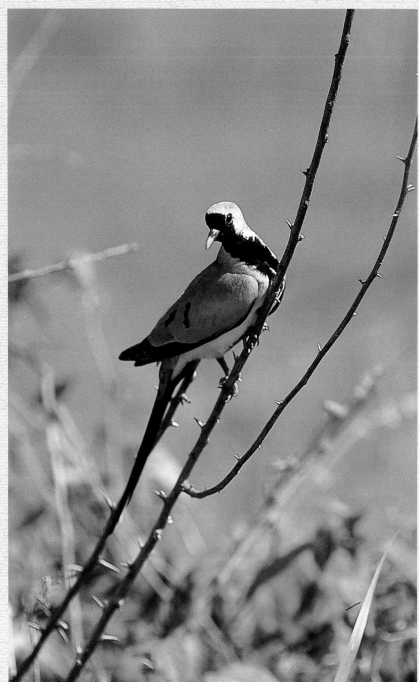

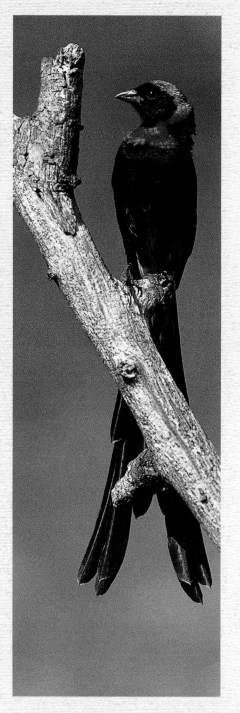

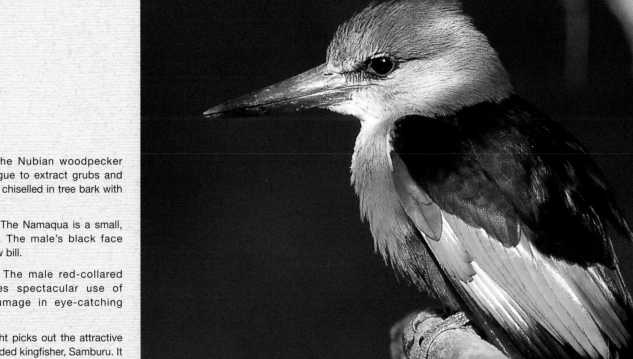

Opposite, left: The Nubian woodpecker uses its long tongue to extract grubs and insects from holes chiselled in tree bark with its sharp bill.

Opposite, centre: The Namaqua is a small, long-tailed dove. The male's black face highlights its yellow bill.

Opposite, right: The male red-collared widowbird makes spectacular use of its breeding plumage in eye-catching display flights.

Right: Dappled light picks out the attractive hues of a grey-headed kingfisher, Samburu. It often perches near water but its main diet is insects rather than fish.

Overleaf: The helmeted guineafowl is found in more southerly regions than its vulturine cousin. Its raucous call is characteristic of the bushlands of Kenya.

With its gleaming red eye, ginger tonsure, cobalt-blue chest, and cape of black and white ribbons, there are few more majestic birds than the vulturine guineafowl.

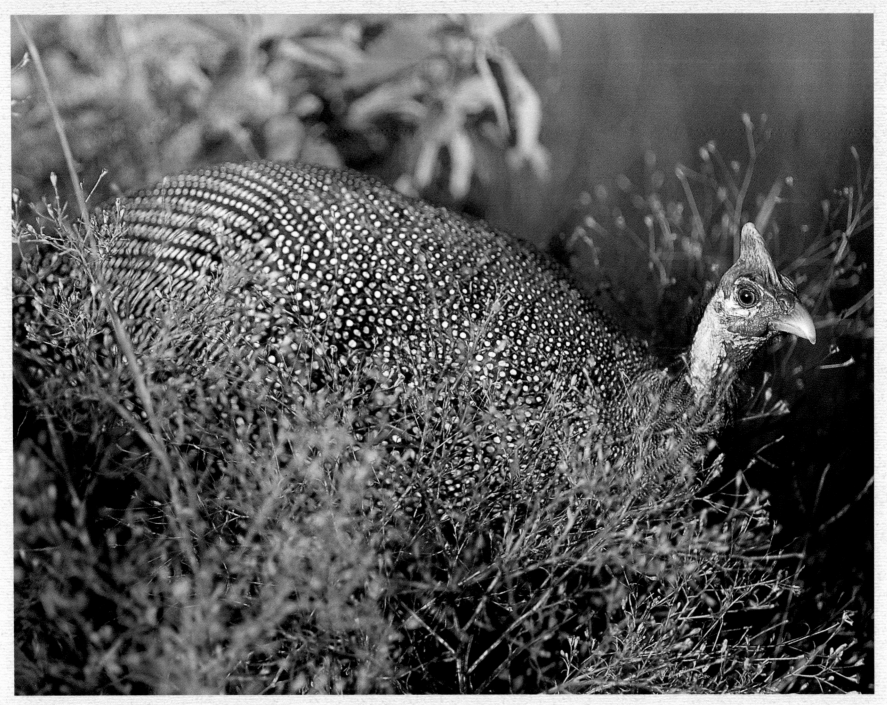

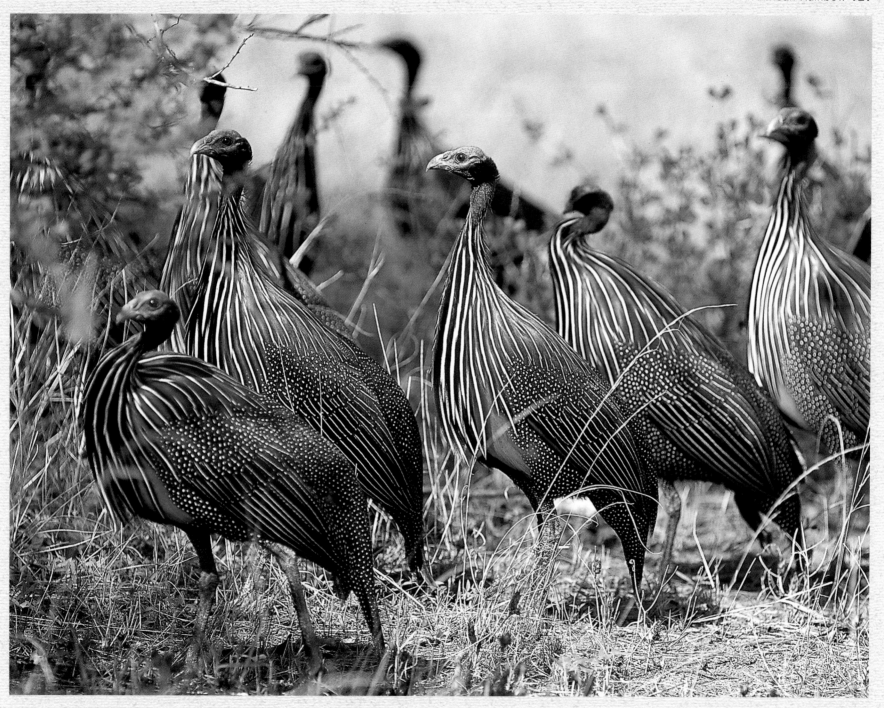

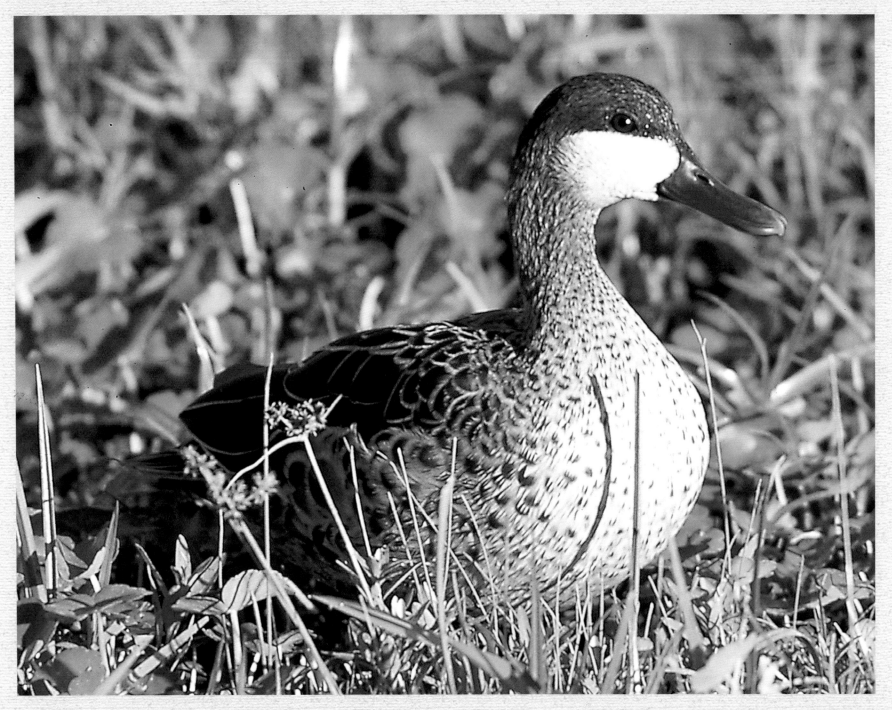

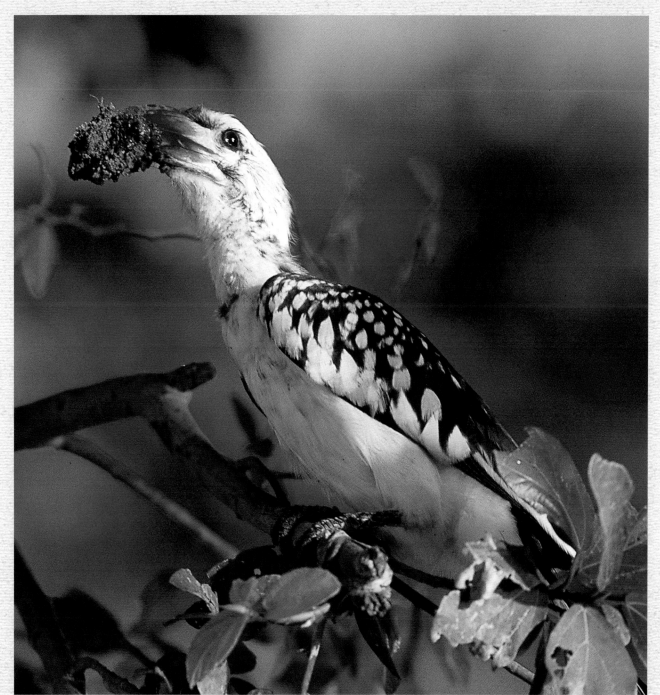

Opposite: The red-billed teal is common on the freshwater lakes of East Africa.

Right: The red-billed hornbill will use this mud to seal the female in her nest cavity while she incubates her eggs. A slit is left through which the male supplies food.

Following pages: The paintbox colours of the grey-crowned crane are shown to best effect during its courtship dance.

The yellow-billed stork feeds in shallow water, snapping up prey it has disturbed with its feet.

A black-winged stilt at Amboseli, Kenya, demonstrates its name. With its improbably long legs, it searches for food in deeper water than most other waders.

Flamingos at Lake Bogoria, Kenya.

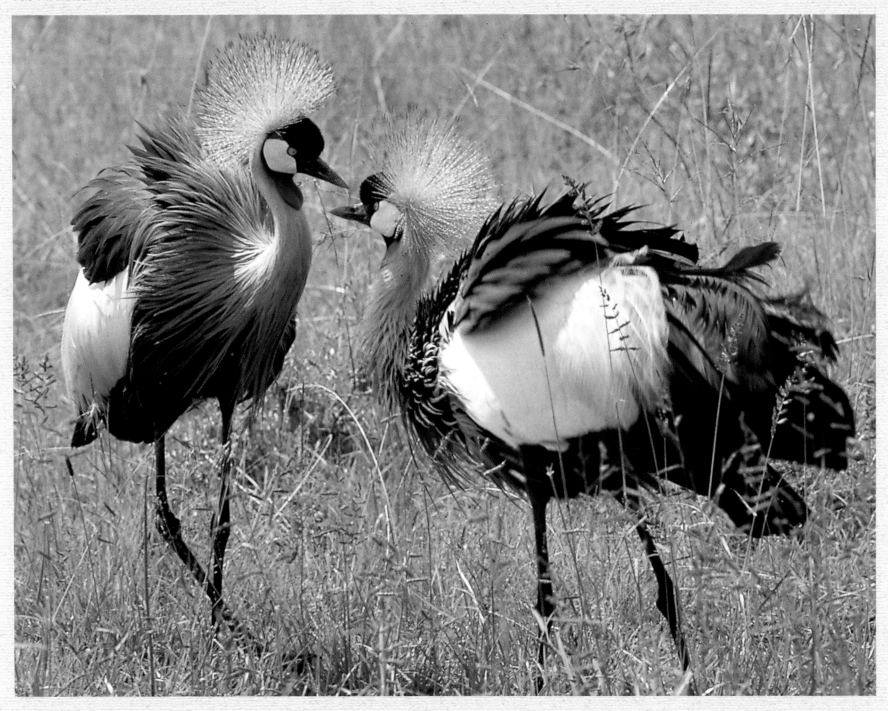

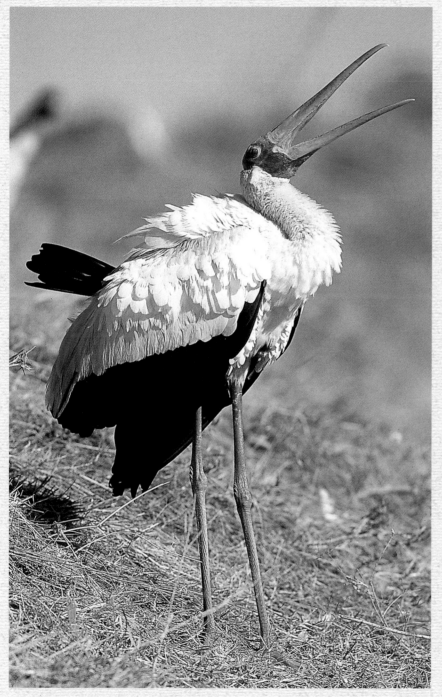

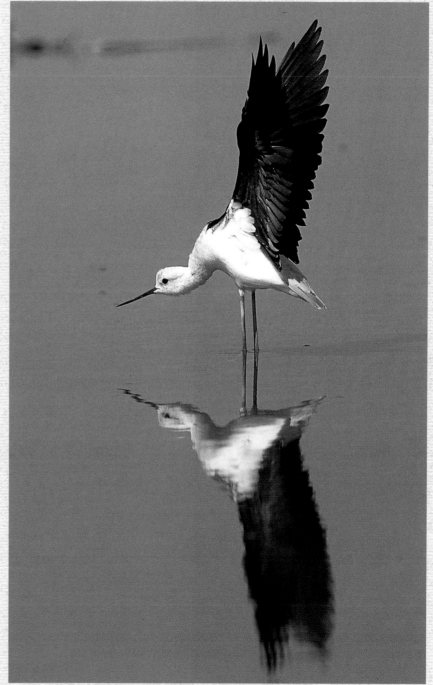

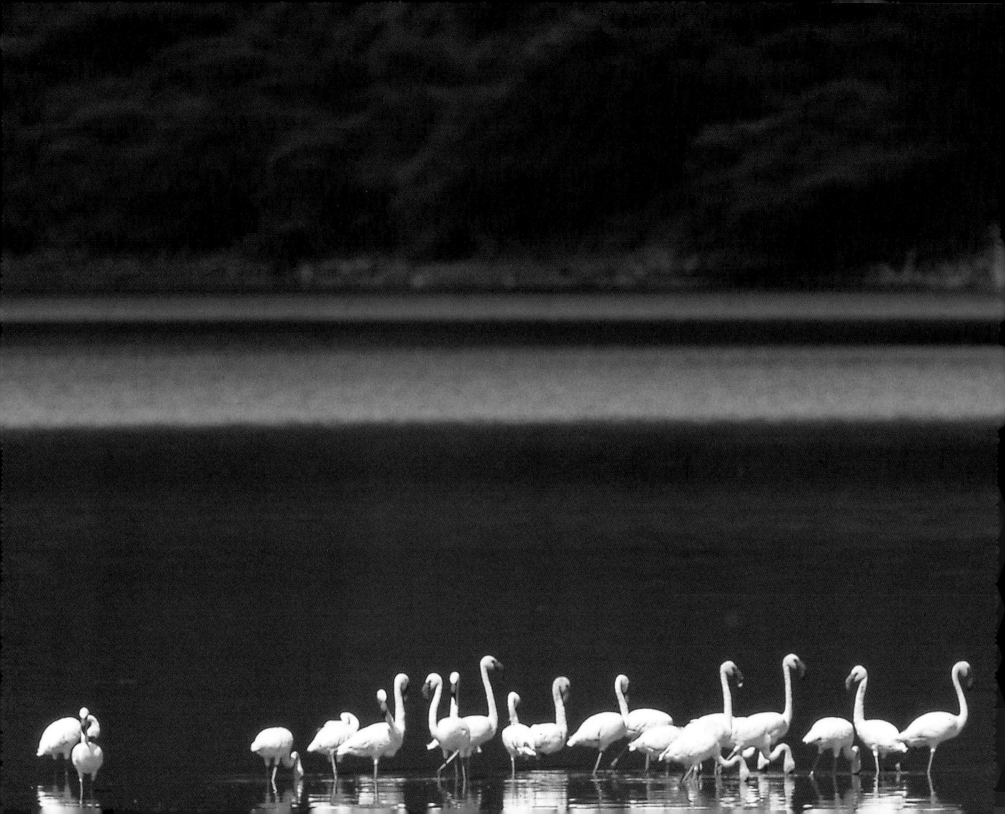

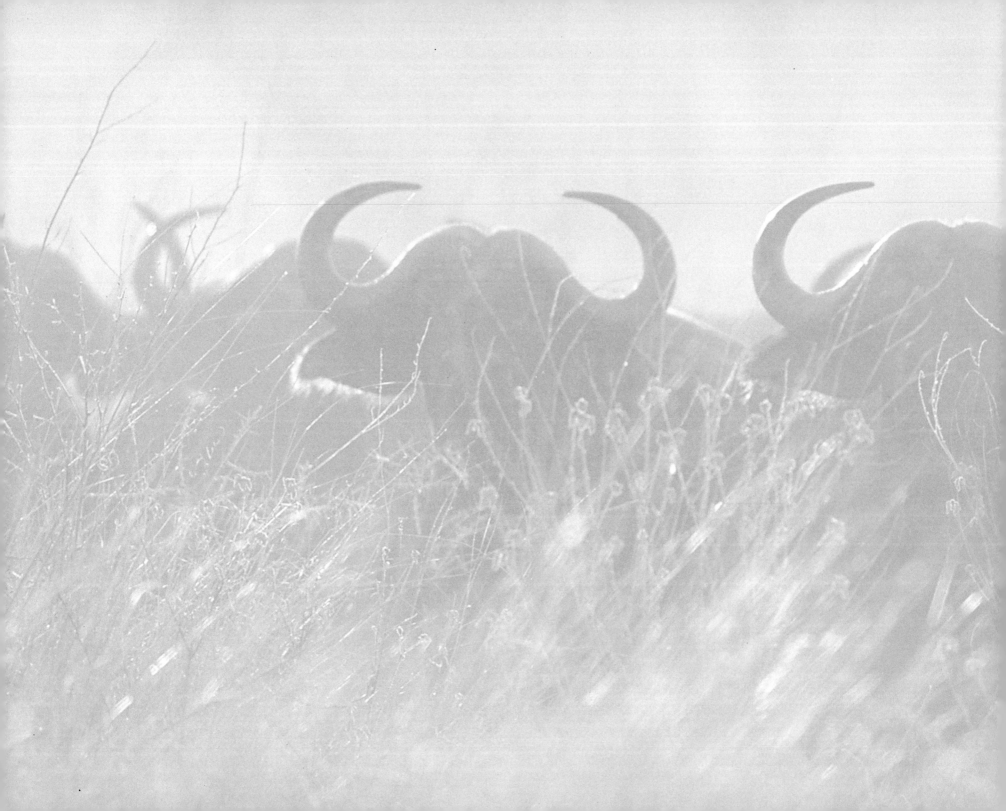